Remembering
Wilmington

T0122699

Wade G. Dudley

TURNER
PUBLISHING COMPANY

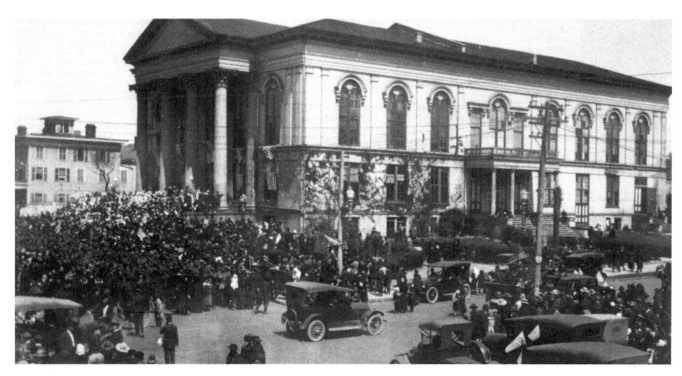

Amid flags and flowers, a crowd gathers at City Hall around 1919.

Remembering

Wilmington

Turner Publishing Company
4507 Charlotte Avenue • Suite 100
Nashville, Tennessee 37209
(615) 255-2665

Remembering Wilmington

www.turnerpublishing.com

Copyright © 2010 Turner Publishing Company

Library of Congress Control Number: 2010926212

ISBN: 978-1-59652-688-4
ISBN-13: 978-1-68336-906-6

Printed in the United States of America

CONTENTS

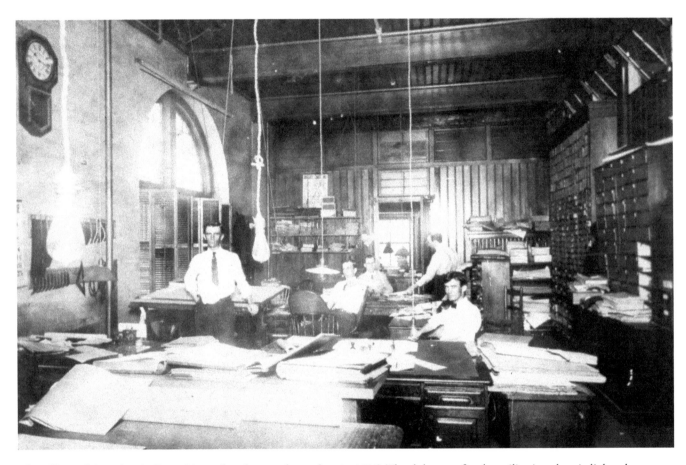

The offices of the Atlantic Coast Line railroad were a busy place in 1906. Thank heaven for the utilitarian electric lights that permitted the offices to run just like the trains: around the clock.

ACKNOWLEDGMENTS

This volume, *Remembering Wilmington,* is the result of the cooperation and efforts of many individuals and organizations. It is with great thanks that we acknowledge the valuable contribution of the following for their generous support:

The New Hanover Public Library
Cape Fear Historical Society
Amon Carter Museum, Fort Worth, Texas

Thanks as well to the (always helpful) staff of the Verona Joyner Langford North Carolina Collection at East Carolina University.

PREFACE

The oldest land grant remaining that relates to a settlement on the east bank of the Northeast Cape Fear River dates to 1733, though Englishmen probably lived there some years earlier. The area had several names: New Liverpool, New Town, and Newton. However, when the Assembly of North Carolina incorporated the village as a town and township in 1739, Governor Gabriel Johnson insisted that it be named Wilmington in honor of his patron, Spencer Compton, earl of Wilmington.

As settlements expanded along the upper Cape Fear River system, colonial Wilmington gained importance as the only deepwater port in North Carolina. Cotton, tobacco, and naval stores (tar, pitch, rosin, and turpentine) floated downstream to join rice and indigo in its warehouses. Loaded on coasters or oceangoing vessels, these raw materials provided credit for manufactured goods from English merchants. Despite commercial success, Wilmington led North Carolina's resistance against taxation, including armed resistance to the Stamp Act in 1765. Joining in revolution, local citizens paid a steep price when the Royal Navy captured the town. British troops used Wilmington as a base in the latter stages of the war.

After securing freedom in 1783, the port of Wilmington grew even richer. Completion of the Wilmington and Weldon Railroad in 1840, linking the port to the interior of the Carolinas and Virginia, made the city an important hub on the East Coast. In 1861, when its citizens rose in a second (attempted) revolution, Wilmington became one of the most important cities in the South. By 1864, with the loss or close blockade of its sister ports, Southerners knew Wilmington as the terminus of the "Lifeline of the Confederacy," where blockade runners poured cargo and money for General Lee's Army of Virginia. Wilmington prospered—until the forts guarding it fell in 1865.

As a port and a railroad terminus (eventually, five railroads would have terminals in the city), Wilmington recovered quickly. It became known as a Republican stronghold and a city where former slaves and freemen could prosper. In 1898, any hope of equality for African Americans ended in an overthrow

of the local Republican government. This marked the beginning of Jim Crow and strict segregation in Wilmington that would not truly end until well after 1970.

Wilmington is known as the "Port City" for good reason. Through two world wars, its citizens gave strong support to the United States whether in service, shipments, or shipbuilding. That such activities brought prosperity, frequently reflected in magnificent homes and public buildings across the years, remains secondary to the patriotism of Wilmington's citizens.

Photographs from as early as 1860 reveal that any narrative about Wilmington, located on a relatively thin strip of land between the Cape Fear River and the Atlantic Ocean, must necessarily be somewhat of a watery tale: a story of beaches, sounds, inlets, shoals, river, boats, ships, ferries, and docks. As such, much of this excursion is regional in nature, reaching across sounds and river by railway, tramway, and boats to local beaches—especially Wrightsville Beach. The tourism that resulted from its favorable location is just as important to the story of Wilmington as any business within its city limits.

This book is a history, of sorts, but a history told primarily with photographs: seconds in time captured by the flash of a camera. I have made no attempt to be thematic, though I certainly think themes emerge. And I make no claim that this is a "complete" history. It is not. However, I do think it captures much of the spirit of the grand old Port City of North Carolina, and of the fun-loving, hard-working, sun-worshiping souls who have had the luck to reside therein.

With the exception of cropping images where needed and touching up imperfections that have accrued over time, no changes have been made. The caliber and clarity of many photographs are limited by the technology of the day and the ability of the photographer at the time they were made.

—*Wade G. Dudley*

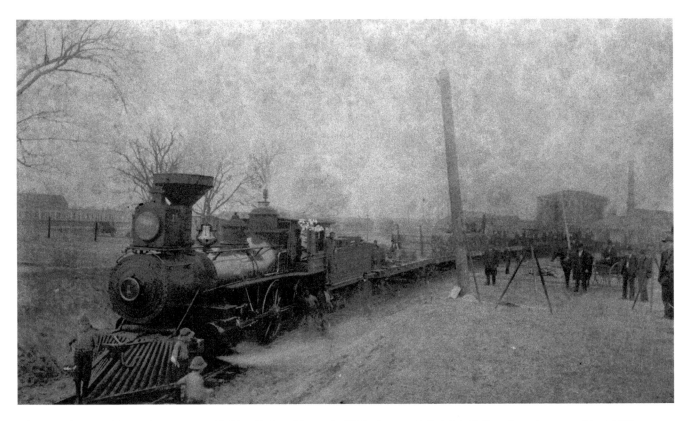

The completion of the Wilmington & Weldon Railroad in 1840 (Wilmington & Raleigh Railroad until renamed in 1855) provided Wilmington with a link to regions beyond the watershed of the Cape Fear River. Because the W&W remained functional through most of the Civil War, it earned the nickname (along with its Wilmington terminus) of "Lifeline of the Confederacy."

From Civil War to Spanish-American War

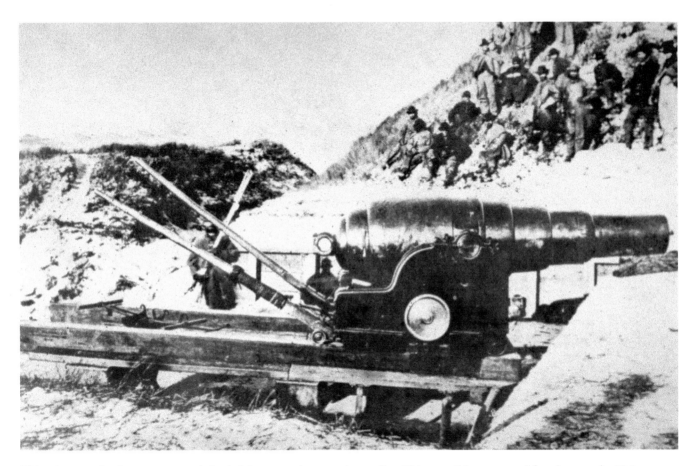

This 150-pounder Armstrong gun defended the seaward approaches to Fort Fisher until its capture. After the war, the Union relocated it to the U.S. Military Academy at West Point as a trophy gun.

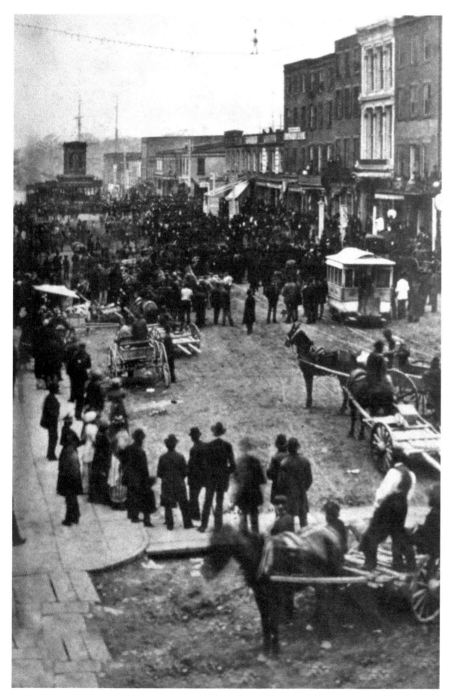

Is the circus in town? Traffic stops to watch a high-wire performer at Second and Market streets around 1880. Not pictured is the mysterious tunnel system, known as Jacob's Run, beneath their feet. Legends abound about the bricked-over old stream: smuggling, escaped prisoners, hidden slaves—work crews even discovered a fishing skiff while repairing the street in 1907. City Market is visible at the far end of the unpaved street.

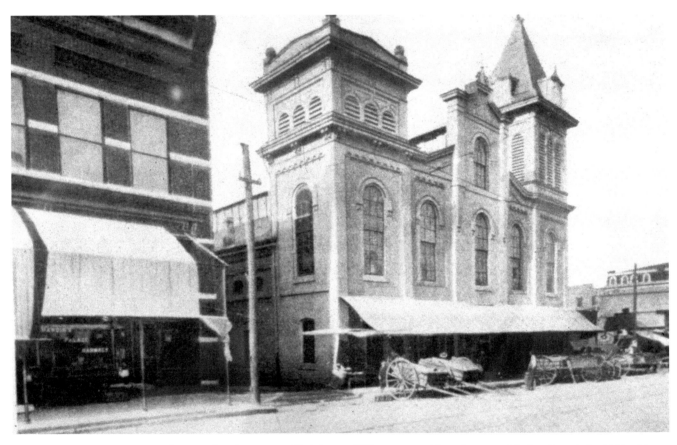

The original open-air City Market stood at the corner of Market and Water streets (thus the name Market Street). In 1881, this new City Market House on South Front Street between Dock and Orange streets replaced it.

To meet the needs of local residents, City Hospital opened at Tenth and Red Cross streets in 1881. James Walker Memorial Hospital replaced the aging structure at this site in 1901, continuing to serve the community into the 1960s.

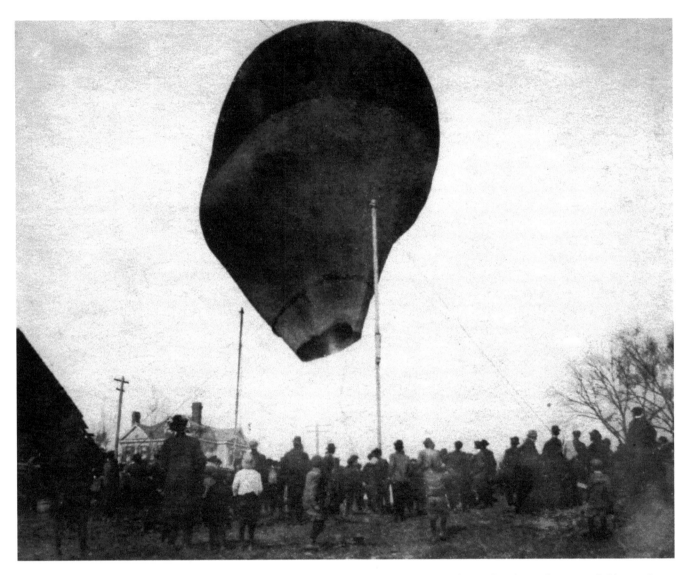

A gas balloon, precursor of dirigibles that would sail above the North Carolina coast in future decades, inflates in a field outside Wilmington in 1890. Passengers—if any brave souls were willing—would get one of the first bird's-eye views of the region.

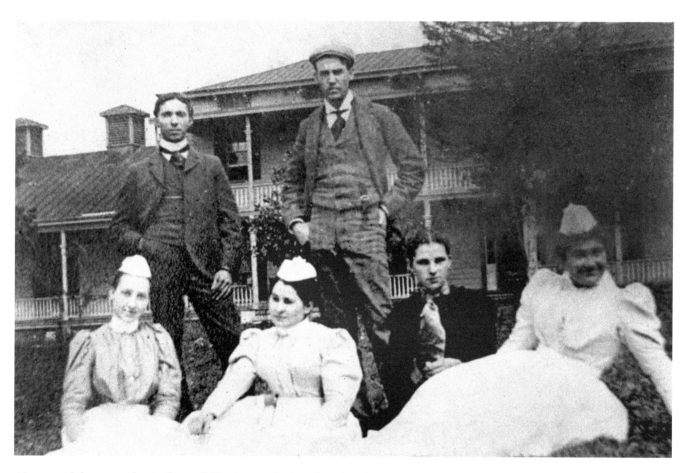

Nurses and doctors gather in front of City Hospital at Tenth and Red Cross streets in the 1890s. The two men standing have been identified, Jim Hall at left and Dr. C. P. Bolles at center.

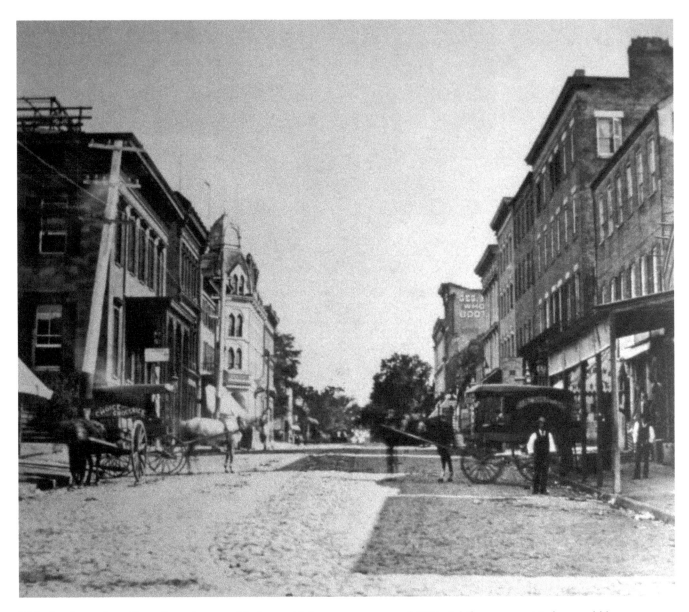

This view is north on Front Street between Market and Princess streets around 1891. A left turn onto Market would leave a pedestrian a quick walk to the ferry landing that serviced Eagle Island and the west side of the Cape Fear River.

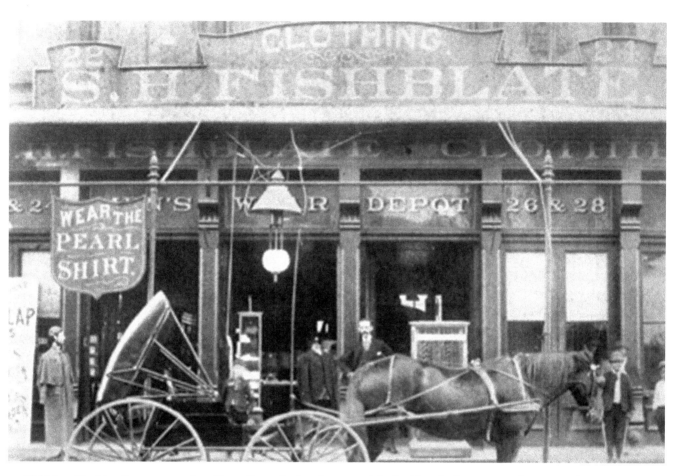

Fishblate Clothing Store operated on Front Street during the 1890s. The building had a cast-iron front, an architectural style of the mid to late 1800s.

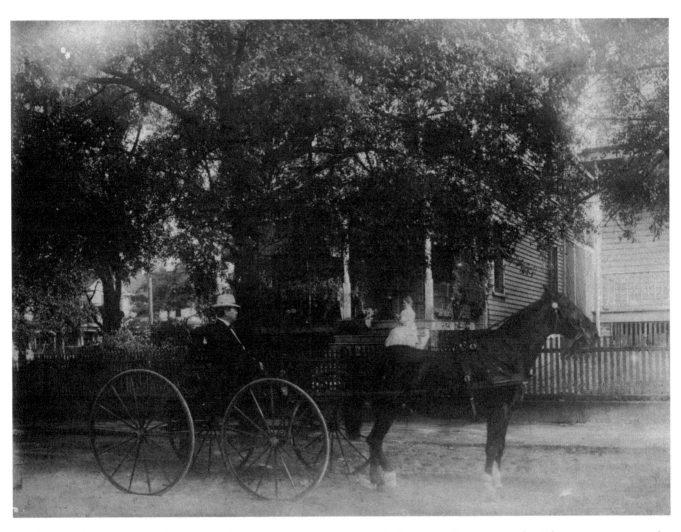

The horse and buggy remained a fixture in Wilmington well into the 1900s. In this idyllic 1890s residential scene, a woman reads on the steps as the gentleman pauses for a moment of admiration.

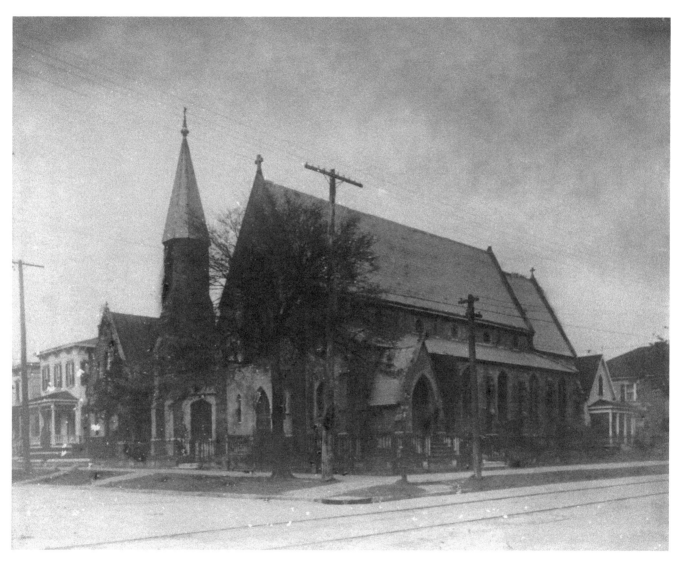

Completed in 1853, St. John's Episcopal Church stood at Third and Red Cross streets. This view, from the late 1890s, shows the trolley tracks that ran along Red Cross Street and utility poles for telephone and electrical lines. In 1955, the congregation moved to a new building.

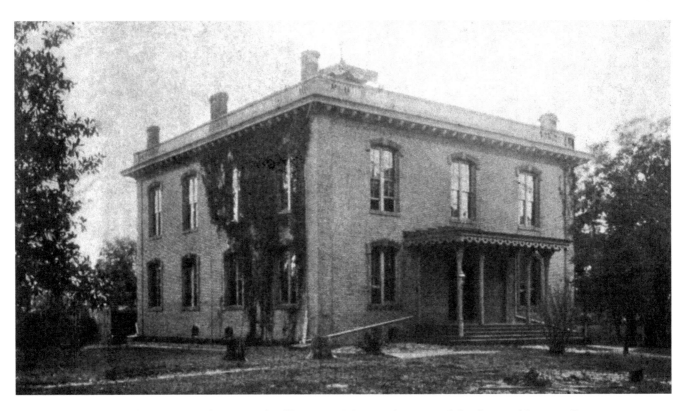

Located on Anne Street between Fourth Street and Fifth Avenue, Tileston Elementary School opened in 1872. From 1900 to 1921, it served as Wilmington High School.

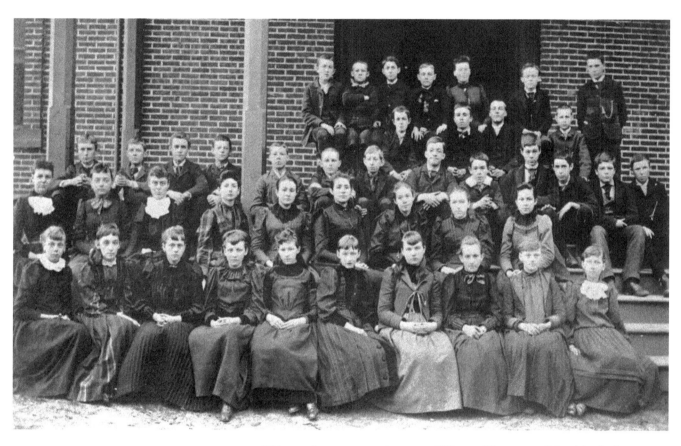

Older students pose on the steps of Tileston Elementary School in the late 1890s.

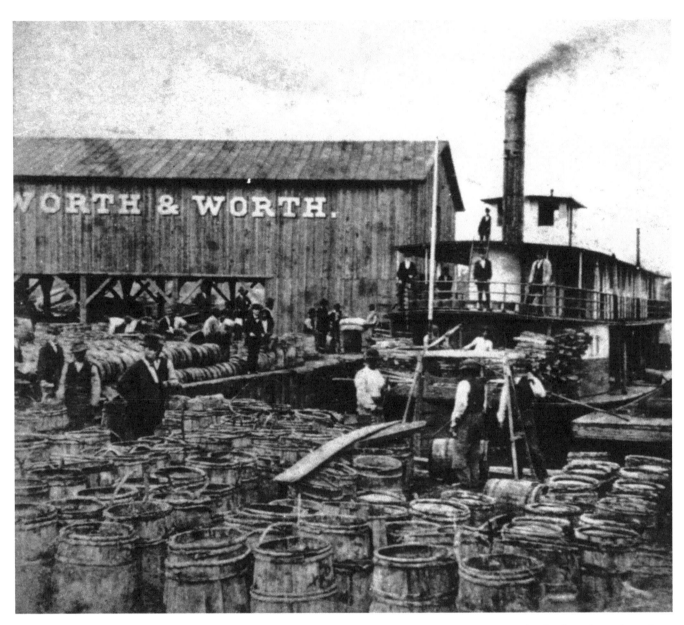

A steamboat unloads barrels of rosin in 1896 at the docks of Worth & Worth (established in 1852), after loading them along the Cape Fear and its tributaries that meandered through the great pine forests of eastern Carolina. Worth & Worth served as agents for the Cape Fear Steamboat Company, storing and transporting the state's agricultural bounty. They also built several steamships: *Flora McDonald, A. P. Hurt,* and *Governor Worth.*

14

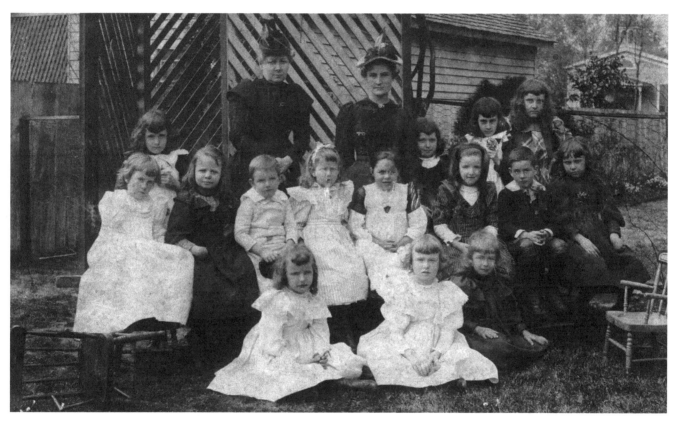

Schoolchildren and two teachers pose in a garden in 1894. The two lads seem a bit subdued—no pulling of pigtails when that heavily outnumbered!

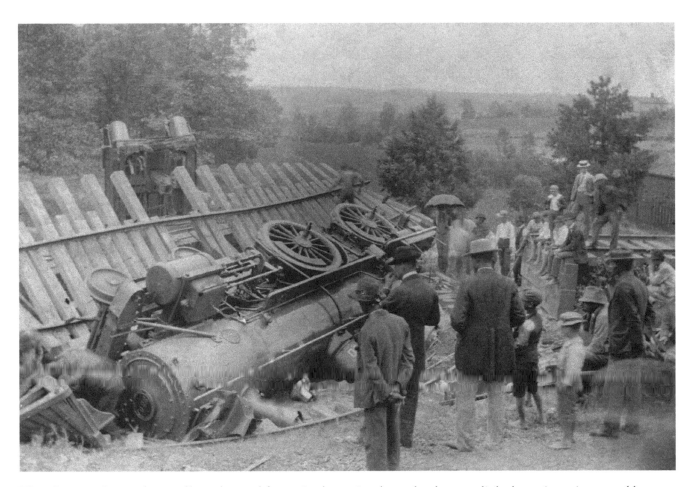

Though cowcatchers took care of bear, deer, and farm animals crossing the tracks, there was little that train engineers could do about washouts beneath railroad embankments—other than be vigilant. This wreck, around 1899, resulted from erosion caused by heavy rains in the Wilmington area.

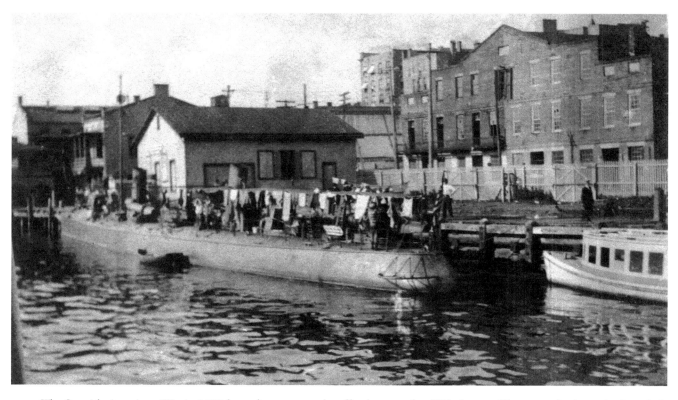

The Spanish-American War in 1898 brought more naval traffic than usual to Wilmington. The crew of a dynamite launch (a torpedo boat) takes the opportunity afforded by harbor and a lovely day to wash, dry, and mend their clothing.

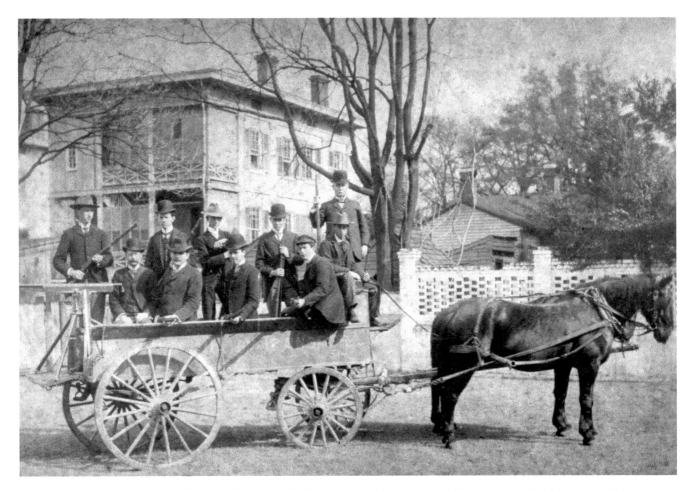

One of the ugliest episodes in Wilmington history took place on November 10, 1898. Democrats and white supremacists combined forces to overthrow the local Republican government. Attackers murdered at least seven citizens during the riot. Groups of well-armed men guarded roads leading from Wilmington, hoping to capture key white and black Republican leaders attempting to flee the city. Alexander Manly, editor of the *Daily Record,* managed to escape in the darkness, aided by his light skin color. Other leaders were not so lucky.

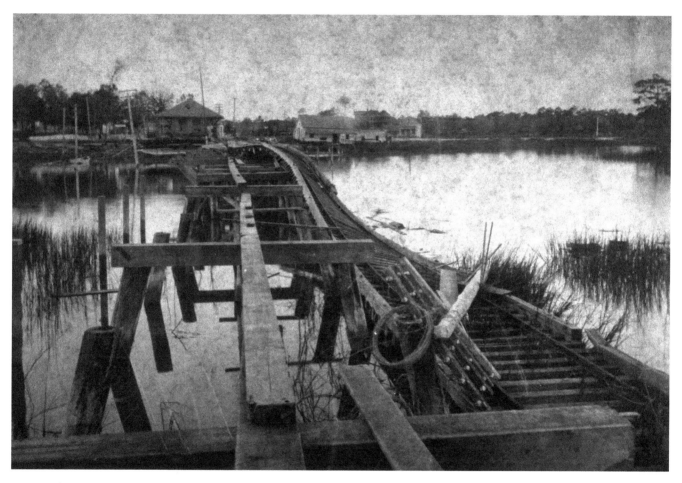

A late-season hurricane, known locally as the "Big Storm of 1899," struck the Wilmington area on November 1. Loss of life accompanied tremendous local damage, including the destruction of the railroad trestle of the Wilmington Sea Coast Railroad that had linked Wilmington and Wrightsville Beach since 1889. An electric trolley line replaced the railroad in 1902.

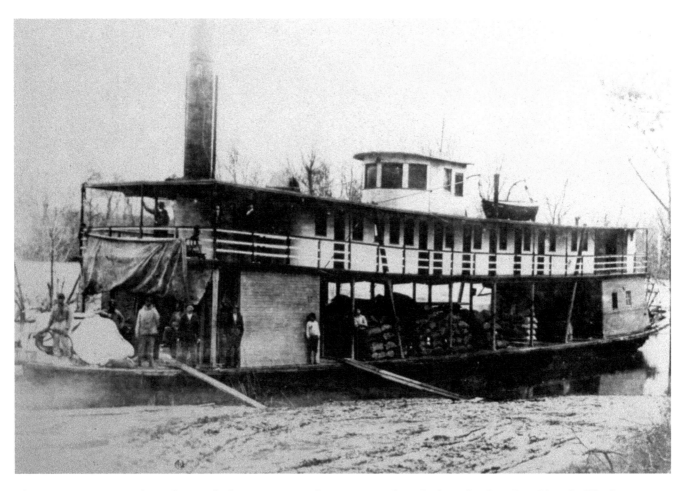

The steamer *A. P. Hurt,* shown here in the late 1890s, carried passengers and goods along the Cape Fear River for Worth & Worth. A steamer of this name operated on the river from the 1860s until 1923. Rebuilt at least once during this period, the modifications allowed the steamer to carry 140 tons. Such flat-bottomed sternwheelers (and, later, propeller-driven steamers) opened the Carolina interior to the Port of Wilmington.

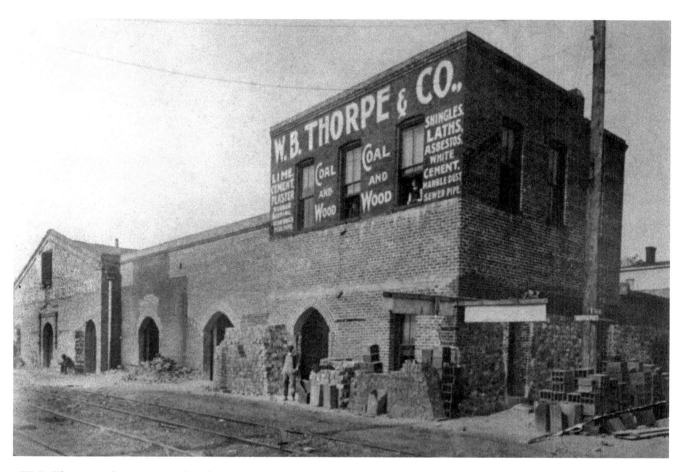

W. B. Thorpe & Company stood at the northeast corner of Water and Anne streets. Offering construction materials to the locals, it also carried coal and wood to replenish steamers. Today, the lower floor of this building houses several shops in the area along Water Street known as Chandler's Wharf.

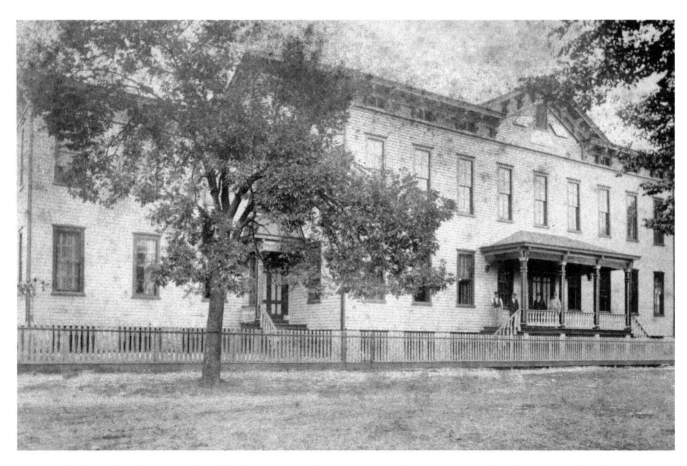

Union School stood at the corner of Sixth and Ann streets between 1886 and 1923. Citizens of Wilmington referred to it as "Big Union School" to distinguish it from a smaller school of similar name, Union Free School, built along Sixth Street in 1857.

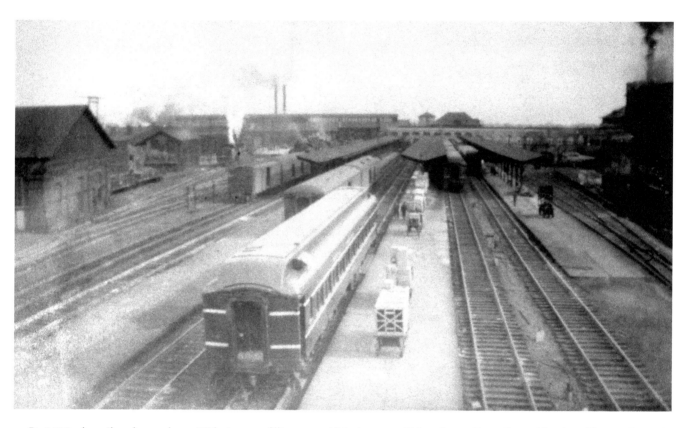

By 1899, the railroad complex at Wilmington, filling several blocks around Nutt Street, Front Street (the site of Union Station), and Red Cross Street, had grown to meet the needs of a thriving port and vacation destination. The next year, the old Wilmington & Weldon merged with the Atlantic Coast Line. That company also chose to make its headquarters in the Port City.

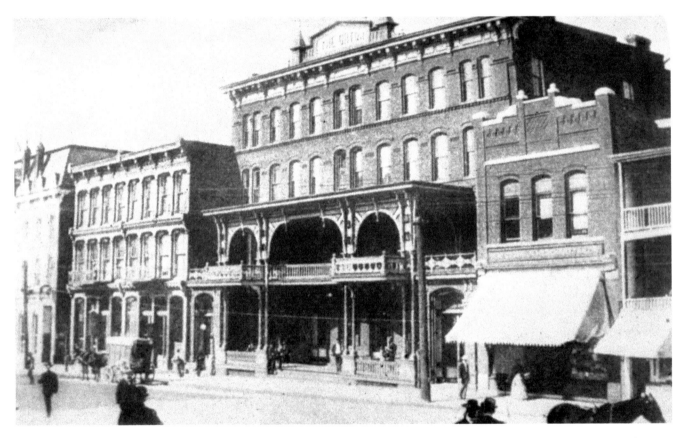

When passengers left Union Station, they frequently walked to the best accommodations in Wilmington—the Orton Hotel at 115 North Front Street. Built in 1886, the Orton maintained a reputation as the finest hostelry in the city until the 1920s. A fire in 1949 gutted the building, which the city subsequently razed owing to safety issues.

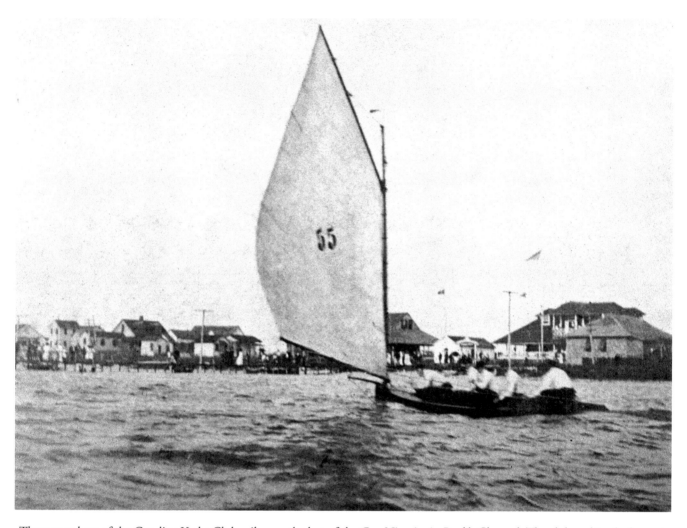

These members of the Carolina Yacht Club sail away the last of the Gay Nineties in Bank's Channel. The club and its docks are in the background. Founded in 1853 at Wrightsville Beach, the yacht club is the second oldest in the United States.

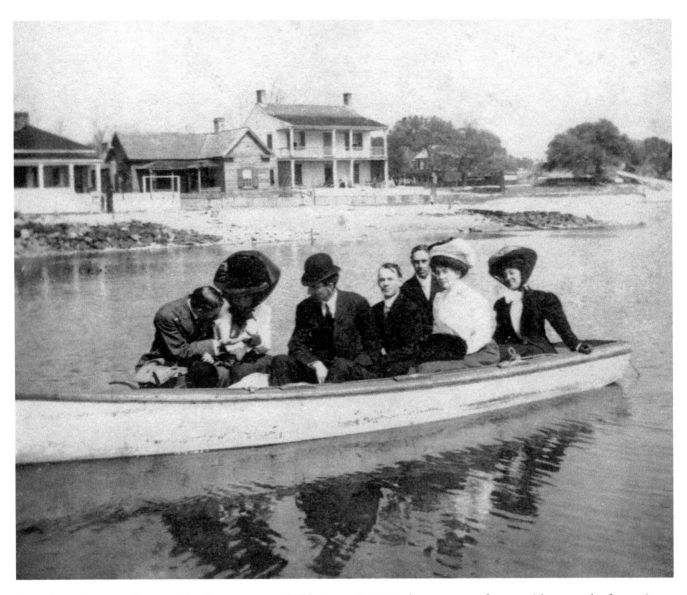

Courtship takes many forms, and in the waters around Wilmington in 1900, that meant an afternoon (chaperoned, of course) floating peacefully along the sound or local creeks.

A New Century and New Beginnings

The coming of electricity brought refrigeration, and with refrigeration came commercially produced ice cream. In 1900, Arctic Ice Cream Company stood on the south side of Princess Street between Water and Front streets. Delicious stuff on a hot, humid Carolina day!

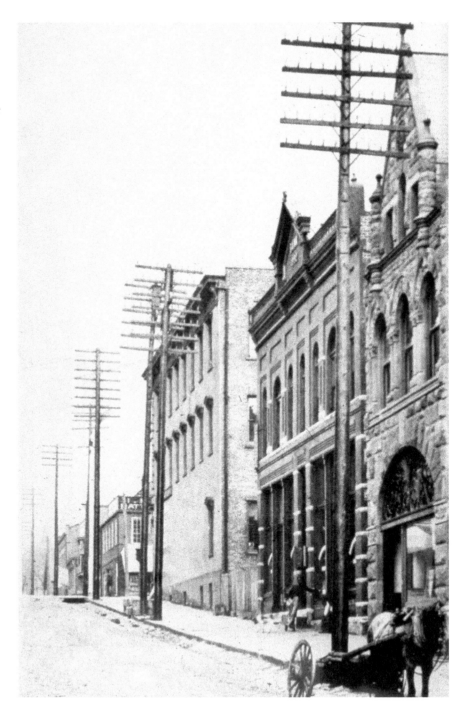

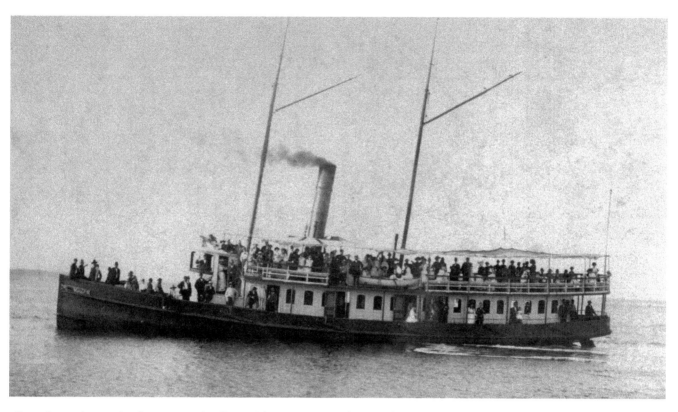

One of several excursion boats operating from Wilmington around 1900, the steamer *Passport* is "standing room only" as it cruises the Cape Fear River, possibly heading to popular Carolina Beach.

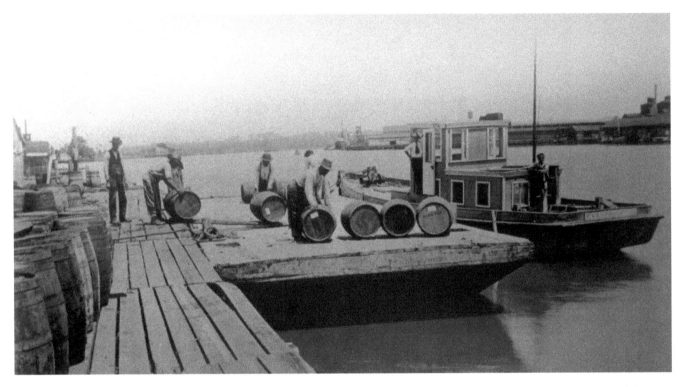

Laborers load barrels onto a "lighter," possibly at a wharf on Eagle Island, around 1900. Lighters transported goods to and from ships that were too large, or for other reasons unable, to reach the wharf.

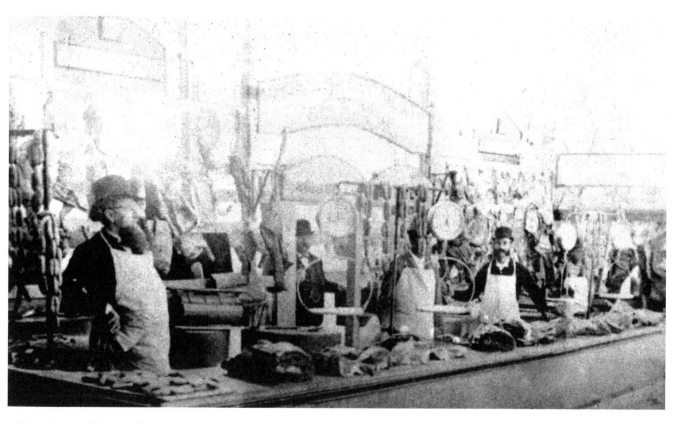

Though it would assuredly not meet FDA standards today, the meat market stalls at City Market House on Front Street provided protein to city dwellers, scraps to the city's stray dogs, and an interesting aroma to all.

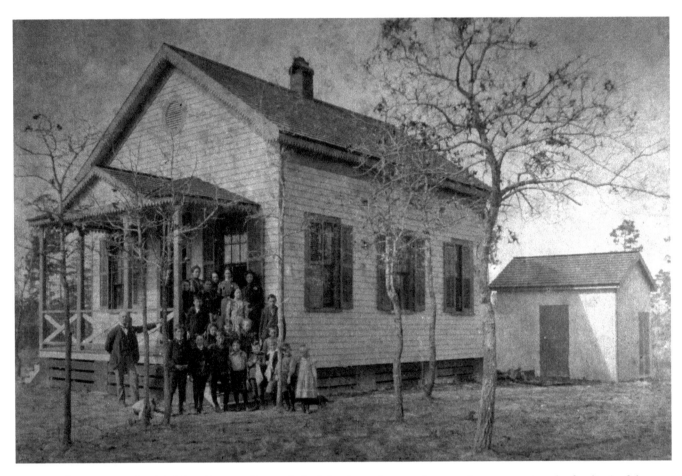

In 1900, this country school in New Hanover County lacked the size and pretentiousness (not to mention the funding) of the Port City's schools. In the 1920s, county and city consolidated their educational systems, eliminating some existing inequalities. The final inequality in education—segregation—had to wait until the 1970s.

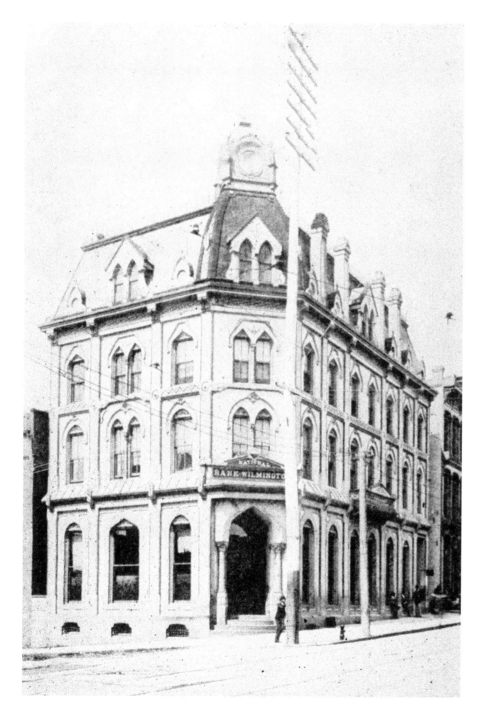

This is a view of the People's Savings Bank (later Peoples Bank and Trust) around 1900. The building, at the corner of Front and Princess streets, dated to 1873, at which time it held the Bank of Hanover. Demolished in 1959, the old building was replaced with a Wachovia Bank.

The old First Presbyterian Church at the corner of Third and Orange streets dominates this view along South Third Street around 1900. Completed in 1861, the building was destroyed by fire on the last day of 1925. Joseph Wilson, father of President Woodrow Wilson, ministered to the members from 1874 to 1885.

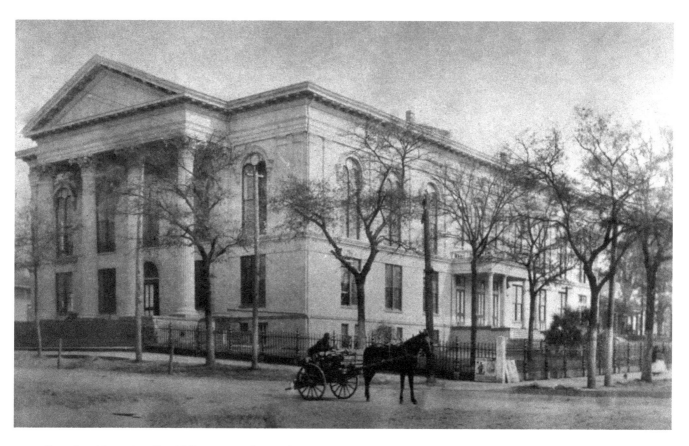

Completed in 1858, City Hall occupies the northeast corner of Third Street. Built in the Classical revival style popular in the mid-1800s, it contained a thousand-seat Opera House as well as room for city offices. This photograph, taken in 1900, shows the impressive Corinthian columns associated with the architectural style.

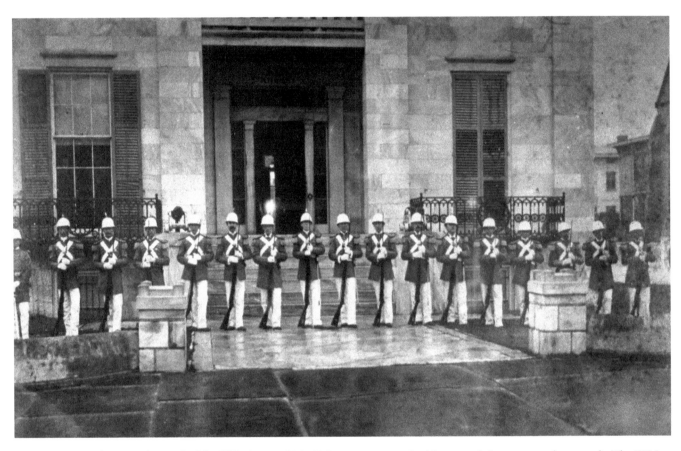

An Honor Guard or Burial Detail of the Wilmington Light Infantry turns out in this turn-of-the-century photograph. The WLI dated their beginnings to 1853. They served as Company G of the Eighteenth North Carolina Infantry Regiment during the Civil War; as Home Guard during the Spanish-American War; and in Battery C, Second Battalion, Trench Artillery during World War I.

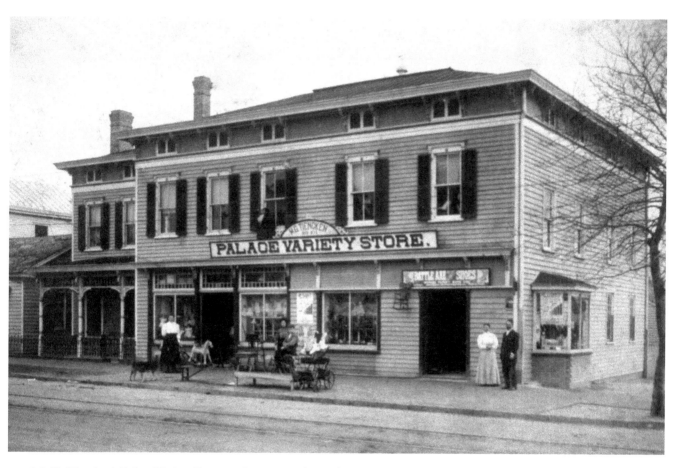

M. G. Tiencken's Palace Variety Store on the corner of Fourth and Castle Street offered, as the name implied, a large variety of goods in 1900. Like many business owners of the time, the family lived above the shop.

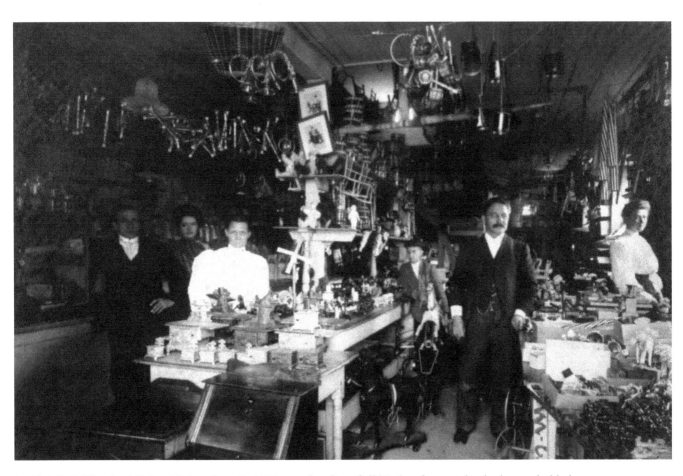

Inside M. G. Tiencken's Palace Variety Store in 1900, merchandise of all kinds—from wicker baskets to hobbyhorses—was available for purchase.

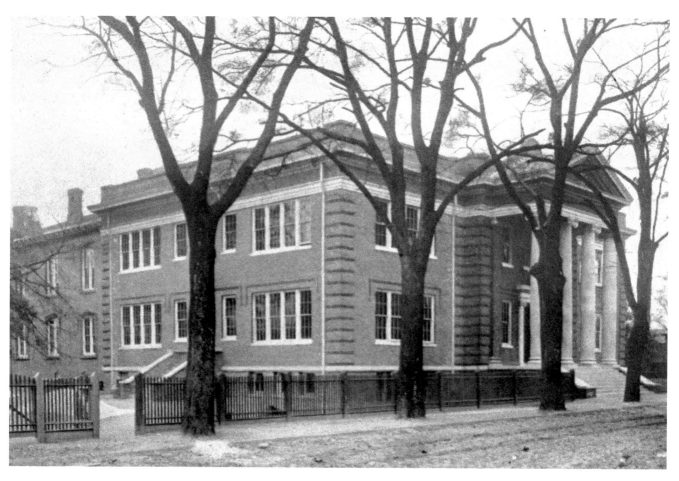

Wilmington High School on Ann Street was expanded twice, notably in 1903 and again in 1910, before its replacement with New Hanover High School in 1921. A sketch of the expansions suggests that this photograph was taken around 1905.

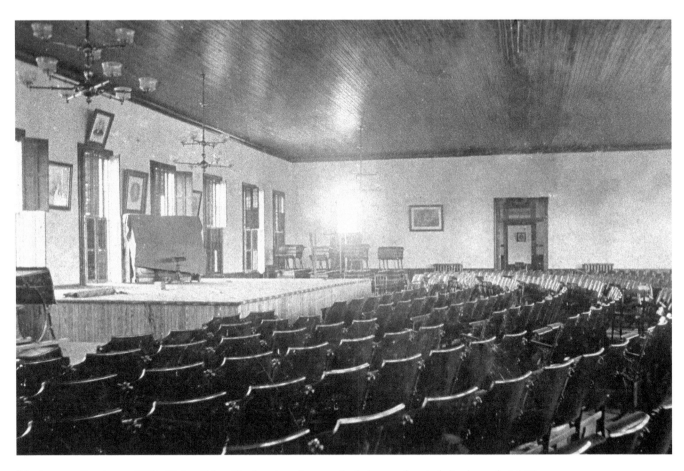

The large auditorium of "Big Union School" echoed to the sound of plays and recitals in the early 1900s.

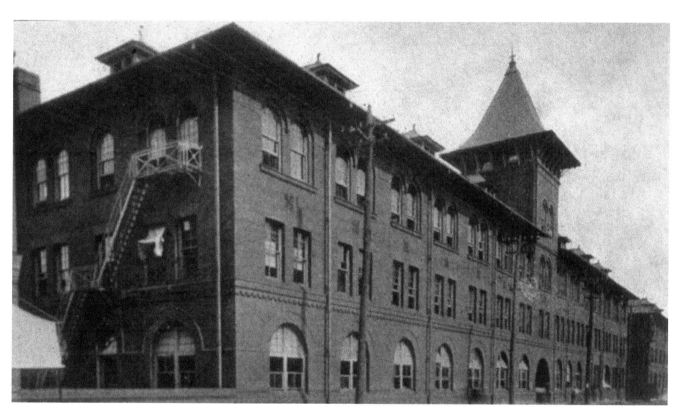

Built in the 1880s, the unique steeple marked the old general office building of the Atlantic Coast Line Railroad on Front Street. In the early 1900s, the railroad guaranteed employment for Wilmington's citizens, and introduced many tourists to the delights of the Port City and its adjacent waters. It was demolished in 1962.

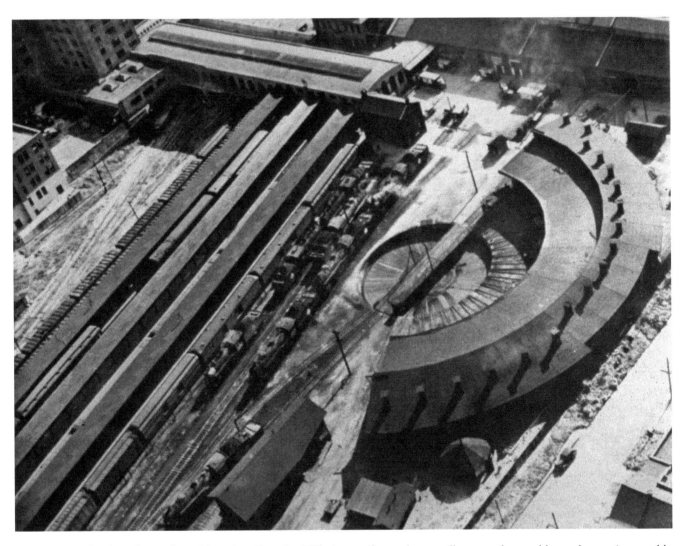

As a terminus for the Atlantic Coast Line, the rail yard at Wilmington featured a roundhouse and turntable, so that engines could be pivoted to haul cars away from the city.

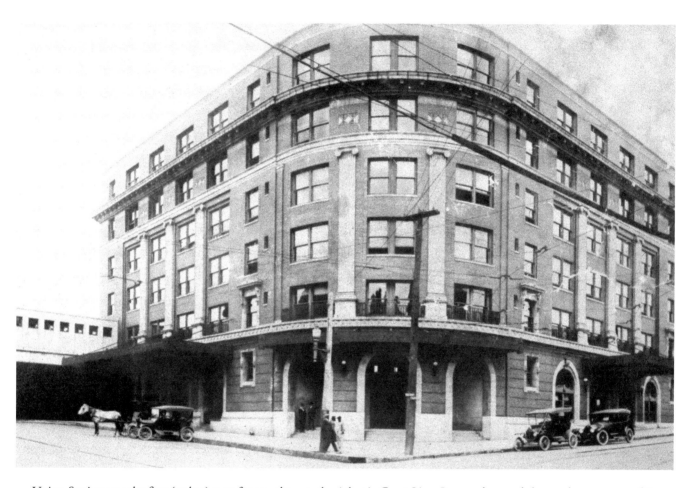

Union Station was the first (or last) stop for travelers on the Atlantic Coast Line. It curved around the northeast corner of Front and Red Cross streets (across Front Street stood the general office building). The headquarters of the ACL occupied the upper floors until 1960, when it relocated to Florida. The building was imploded in 1970 with explosives. This picture, from around 1909, illustrates changing times in Wilmington: horse and buggy at left, automobiles at right.

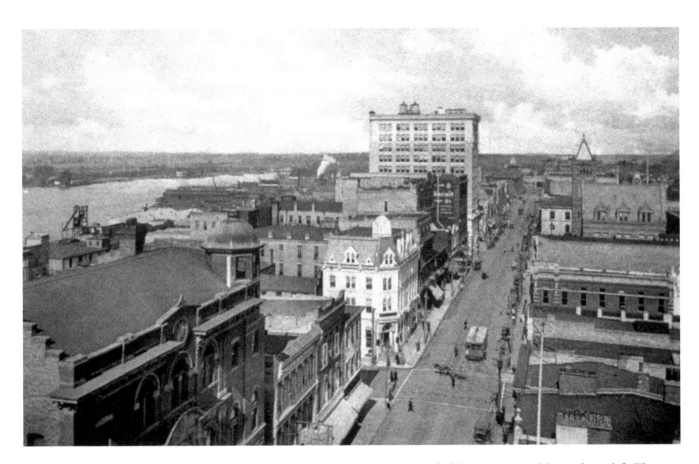

This view of North Front Street in the mid-1900s shows the upper stories and roof of the Masonic Building at lower left. The white structure in the center is the Southern Building, while the Murchison National Bank Building looms at upper center. The steeple of the Atlantic Coast Line's general office building is visible in the distance on the east side of the street, while the Cape Fear flows to the west.

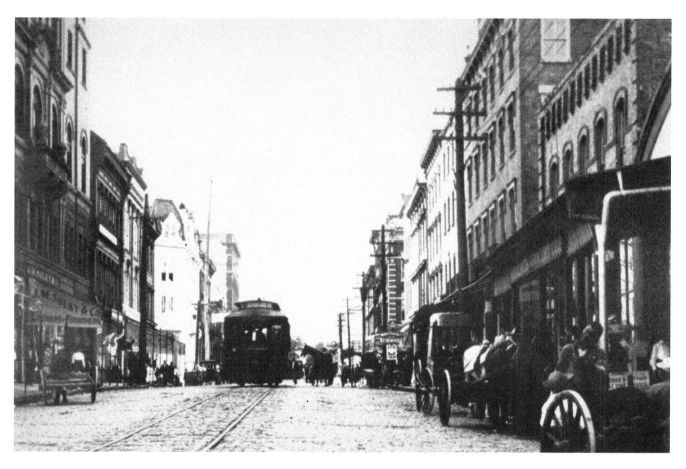

This street-level view along North Front Street (around 1905) illustrates the heavy horse-drawn traffic over the cobbles of the period in the main business district of the Port City. Electric trolley lines and utility poles are visible in the center of the street, both signs of a vitality and wealth not common to every Carolina town. The Southern and Murchison buildings are visible on the distant left. The Purcell House Hotel stands at right.

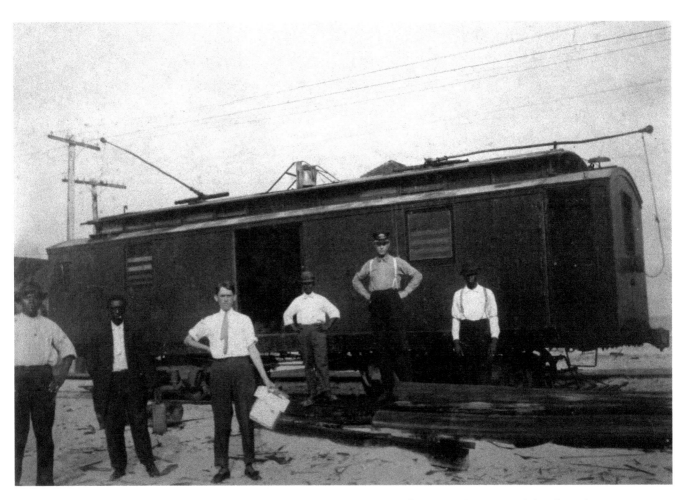

Baggage handlers load a trolley car destined for Wrightsville Beach sometime after 1902. On a normal day, from the 1890s to 1939, Tide Water Power Company operated the trolley system in Wilmington beginning at six o'clock every morning. In 1902, the company added seven stops at Wrightsville Beach, ending at the popular Lumina Pavilion.

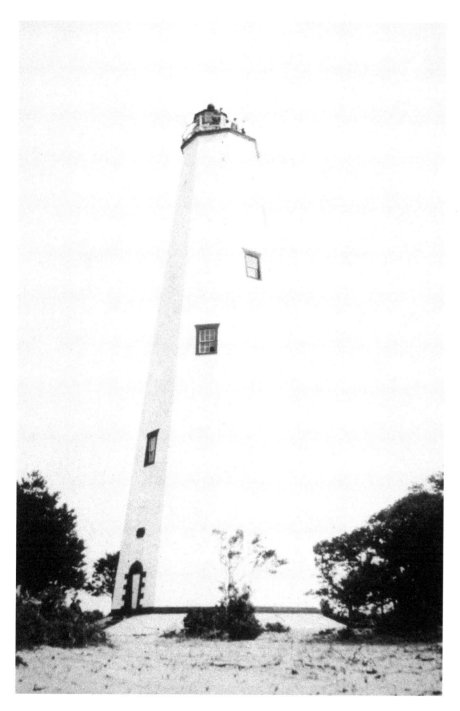

Completed in 1818, the Bald Head Island Coast Guard Tower stood off the mouth of the Cape Fear River, warning sailors of the dangers of Frying Pan Shoals and the coast. Except for the years of the Civil War, it operated until 1935.

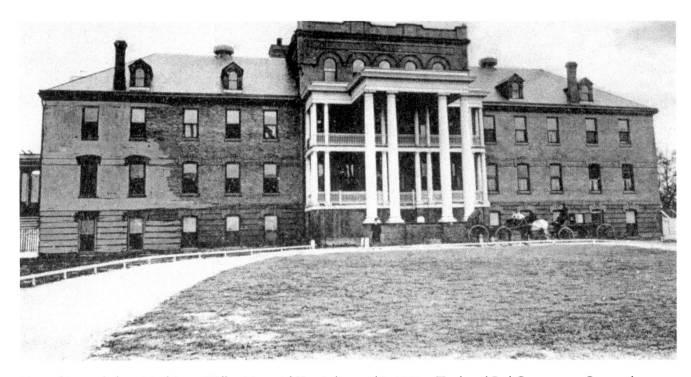

Pictured in 1904, the original James Walker Memorial Hospital opened in 1901 at Tenth and Red Cross streets. Constantly expanded across the years, only the Nurses Residence Hall survived its demolition in 1972.

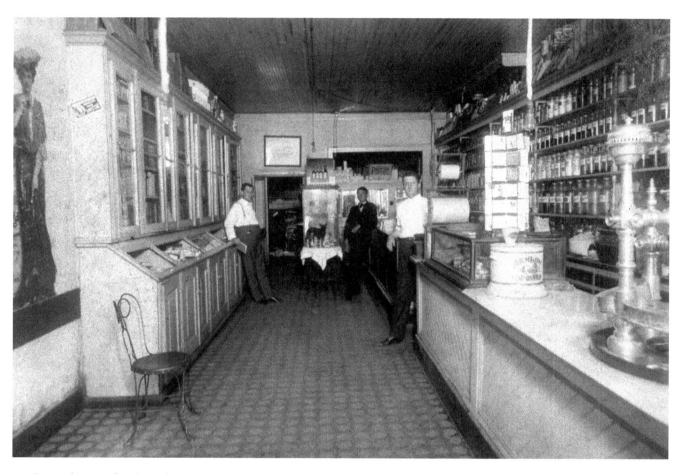

Located on Market Street between Front and Second streets, Shepard Pharmacy filled prescriptions and offered mass-produced remedies as well as carrying a well-stocked ice cream freezer.

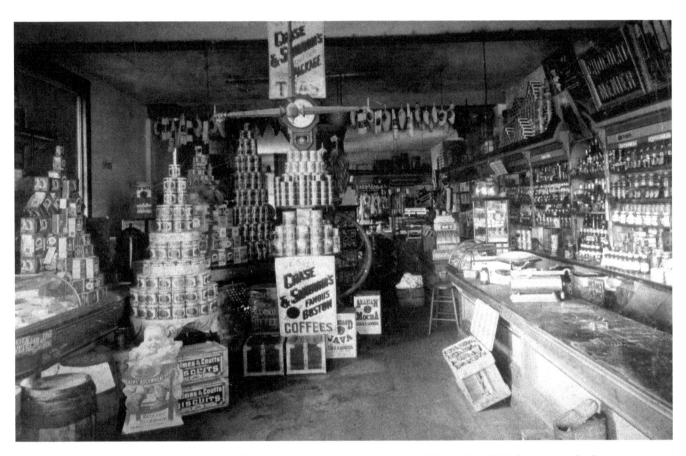

In 1905, Simon Sanders' Grocery Store served customers at the northeast corner of Second and Market streets. Such "Mom and Pop" grocers served the needs of communities long before the coming of the modern supermarket. They usually depended on local farmers for fresh vegetables and meats, but Wilmington's location on the Atlantic Coast Line offered other sources for its merchants.

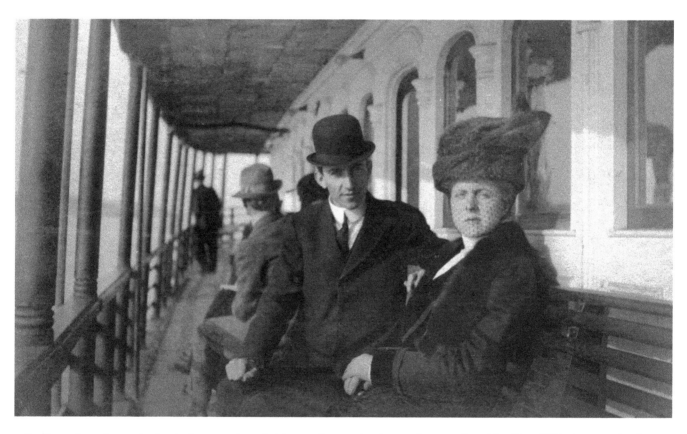

Ladies and gentlemen in the deck seats enjoy a brisk morning on the river as the excursion ship *City of Wilmington* makes its way to Carolina Beach and Southport around 1905.

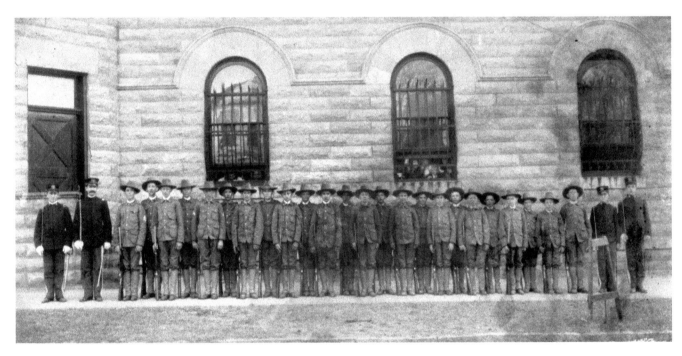

Founded in 1896 by Colonel Walker Taylor, the Brigade Boys Club modeled itself on a similar Scottish organization. Originally, the only criterion for joining was membership in a Sunday school class and regular attendance. Shown here in uniform, the young men and their instructors pose for the photographer in 1906.

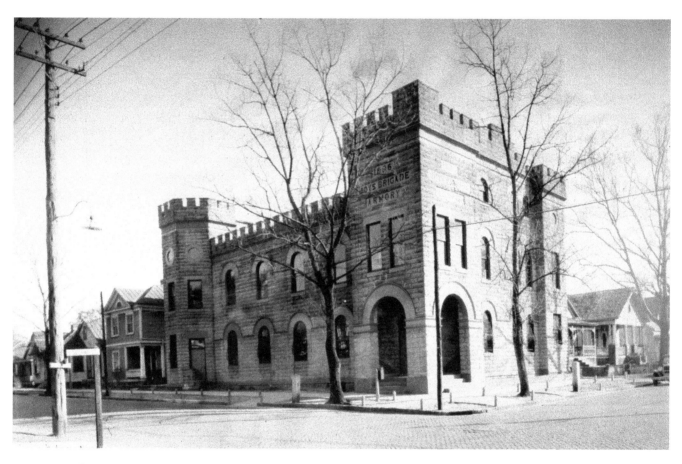

The Brigade Boys Club Armory is pictured a few months after its dedication in 1905. Standing at the corner of Second and Church streets, it remained in use until 1950. Today, the Brigade Boys Club has both male and female members and is affiliated with the Boys and Girls Club of America.

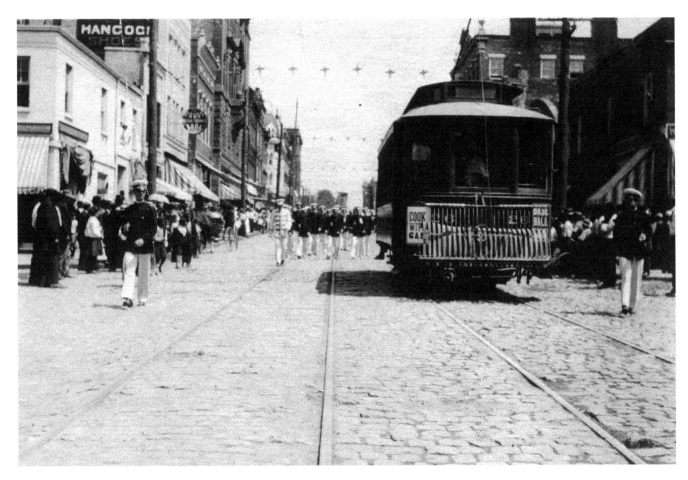

A parade, sometime early in the new century, marches alongside a trolley car near the intersection of Front and Market streets. Though cobblestones had not yet given way to asphalt (a sign of increasing automobile traffic), Wilmington had much to celebrate in the first decade of the twentieth century.

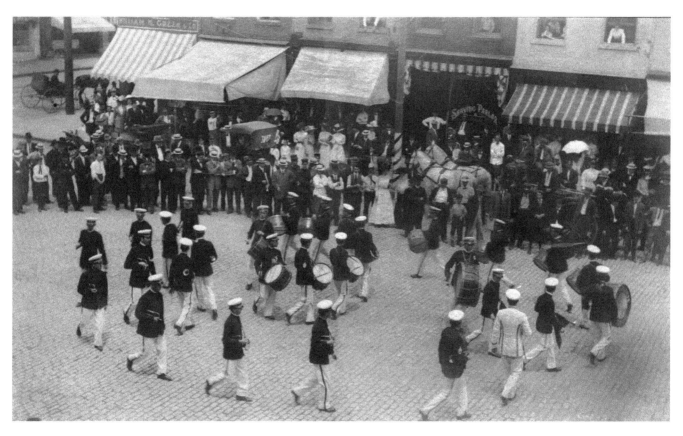

A Wilmington band displays its fancy marching skills on Front Street. Amid all that noise, a team of horses in front of the Shaving Parlor waits quietly, unperturbed.

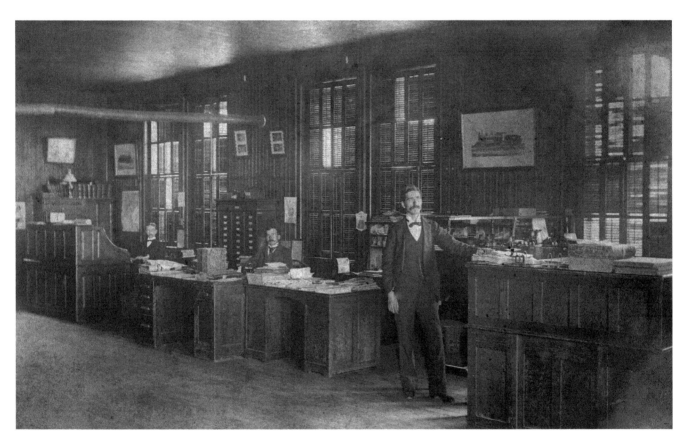

Andrew J. Howell stands in the office of the Wilmington, New Bern, and Norfolk Railroad in Wilmington in 1907. Meant to fill a short-haul niche, the railroad faced competition with the developing rail corporations as well as a short-haul trucking industry that would be blooming by the early 1920s.

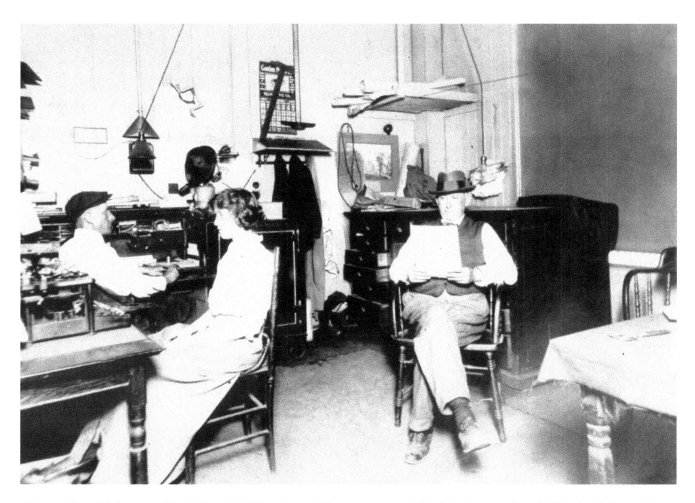

Hanover Iron Works opened in 1903 at 111 Water Street. The company specialized in sheet metal work. Here in 1908, employees seem to be making a diligent effort not to pose for the photographer. In recent times, the business has expanded and improved, and the company is still located in Wilmington.

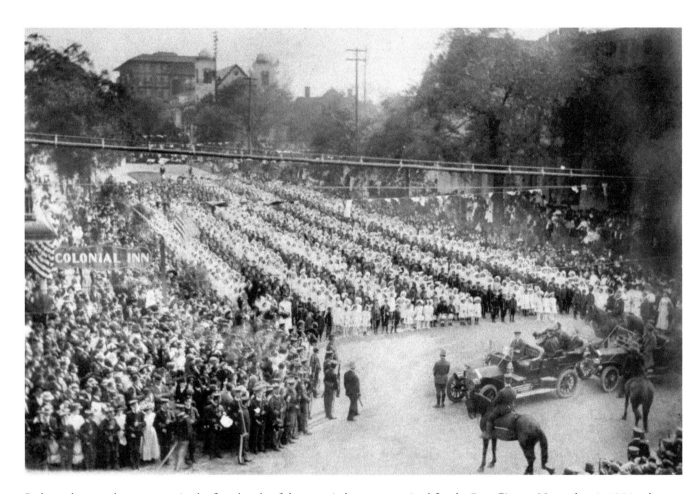

Perhaps the proudest moment in the first decade of the twentieth century arrived for the Port City on November 9, 1909, when President William H. Taft visited Wilmington. Before he spoke, he recognized the children of Wilmington at Third and Market streets, where they had assembled in the shape of a huge American flag.

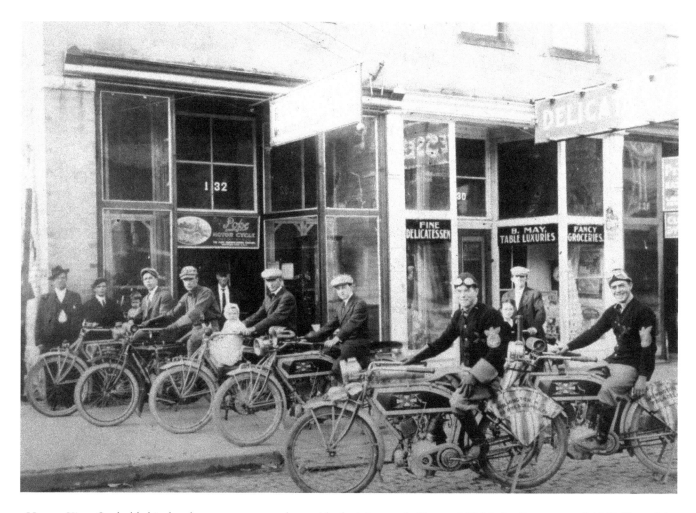

Horace King, Sr., holds his daughter on a motorcycle outside the Motorcycle Shop at 132 Market Street around 1909. Two of the other motorcyclists are preparing to leave for Philadelphia. Since their introduction in 1894, motorcycles had seduced many a lad in Wilmington (and more than a few lasses).

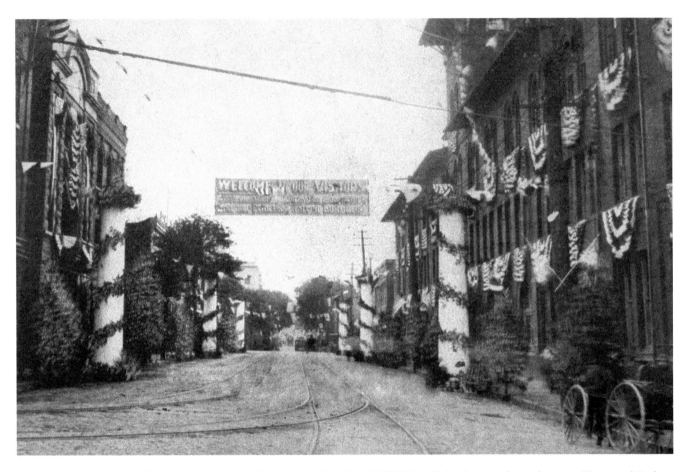

With the Wilmington Light Infantry as a special bodyguard, President Taft followed the decorated parade route (Front and Red Cross streets, with Front Street shown here) to City Hall. More than 15,000 people lined the parade route or packed the streets around the steps of City Hall to hear his speech. Before leaving, the president took a brief cruise along the Cape Fear on the revenue cutter *Seminole*.

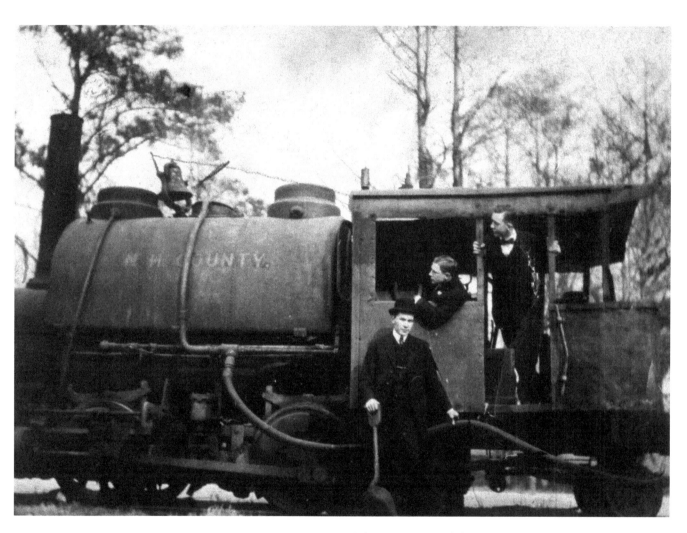

This steam engine belonged to New Hanover County in 1910.

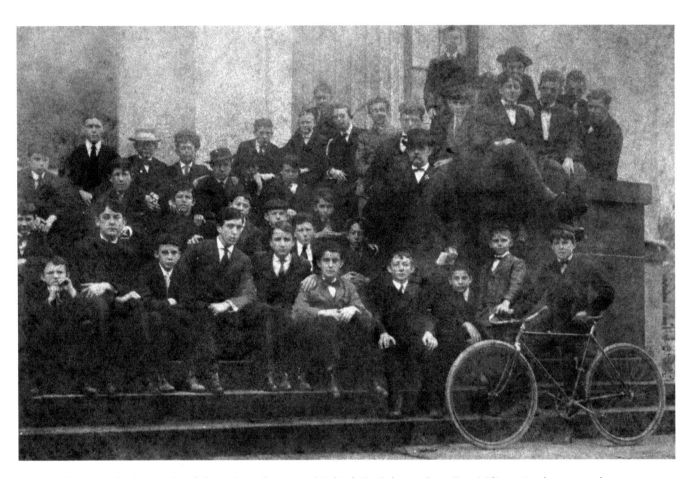

Organized in 1868 by former Confederate brigadier general Raleigh E. Colston, Cape Fear Military Academy served several generations in the Port City. Initially, the young men at this preparatory school wore uniforms and drilled daily. This photograph, taken sometime between 1910 and 1915 on the steps of City Hall, reveals that the school's military codes had been relaxed. Professor Washington Cattlett led the school in these later years.

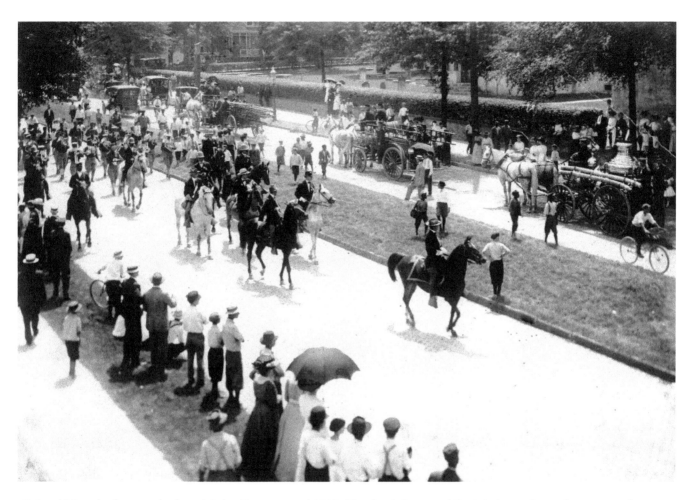

Colonel Metts leads a parade along Market Street around 1910. Newfangled automobiles join horse-drawn fire wagons, the one at upper-right sporting a steam pump, for the march.

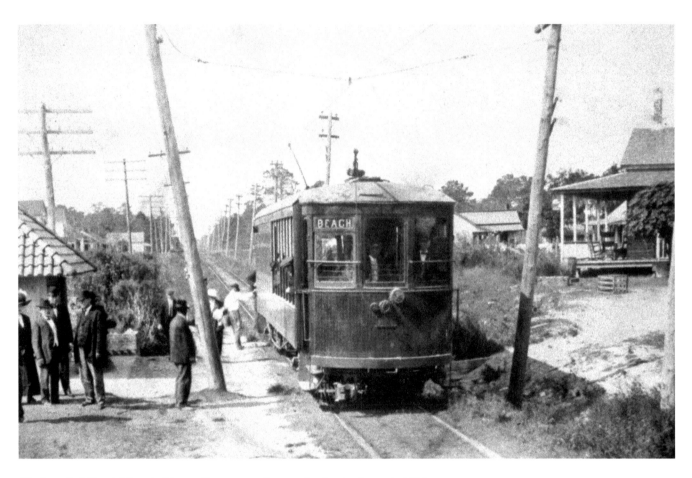

All aboard! A Beach Electric Line trolley stops at Seagate Station in the early 1910s.

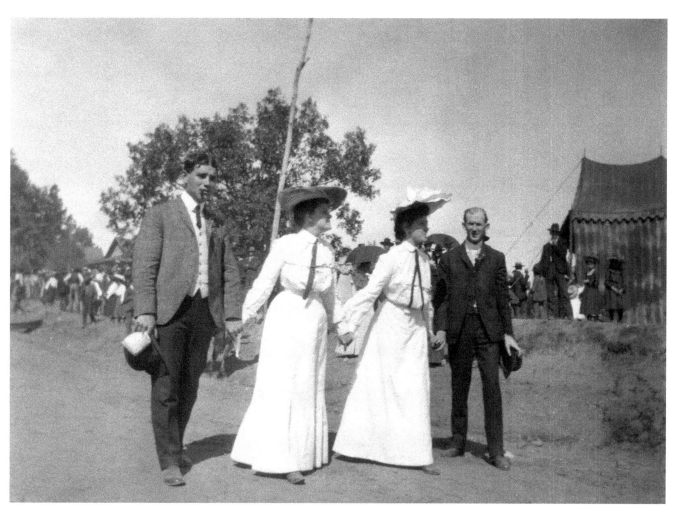

Young and old alike love the circus, as proven by these well-dressed ladies and their escorts sometime around 1910.

A well-trained baboon, doing a great imitation of anyone's favorite politician, seeks to separate circus-goers from their cash. The annual visit by the "Circus Train" and the parade from the train station to an empty local field inevitably drew crowds to the "Big Top."

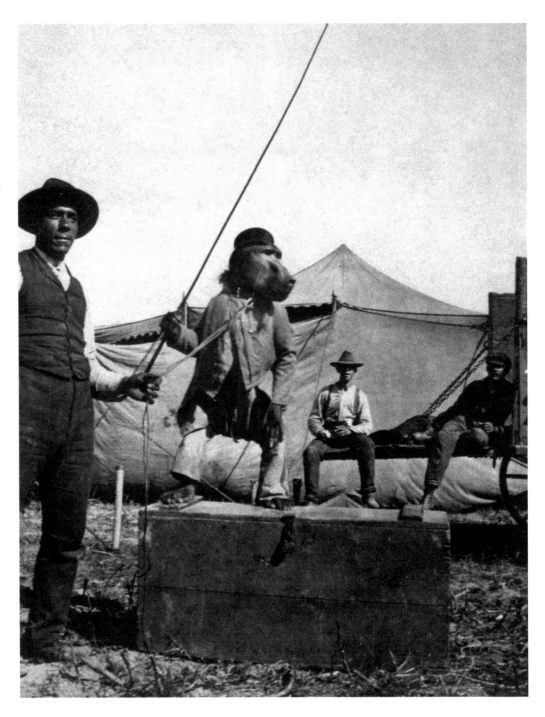

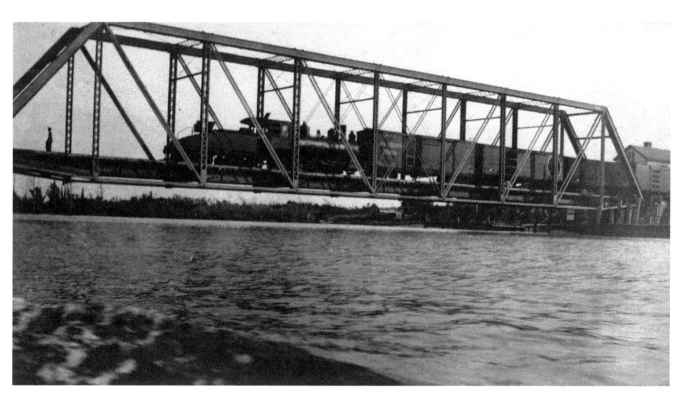

An engine pushes cars across the Hilton Railroad Bridge around 1910.

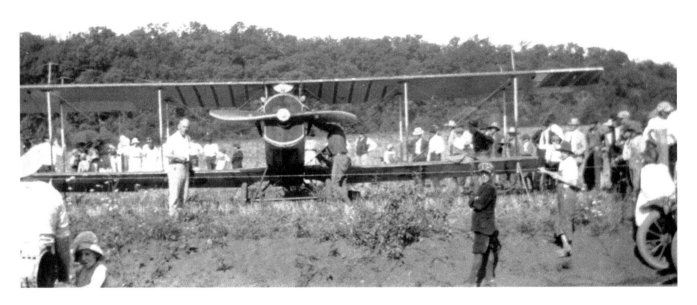

Sometime around 1912, airplanes made an appearance in Wilmington, though it would be 1927 before the Port City built an airport (Bluethenthal Airport) to supplement its rail and river infrastructure. Shown here, a biplane takes advantage of an empty field to enthrall onlookers.

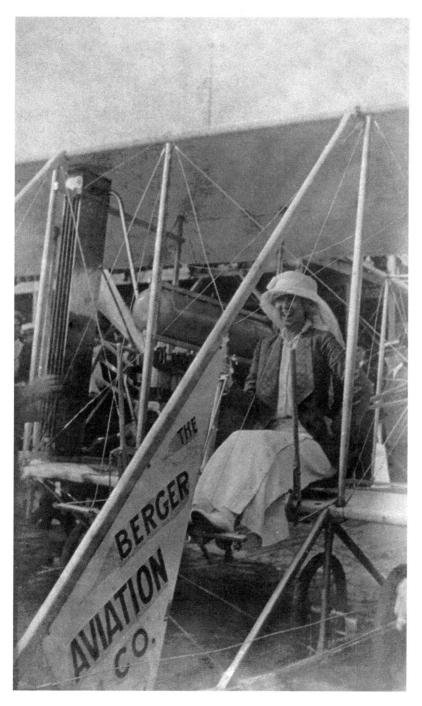

Sometime around 1914, Mrs. Stephen Provost prepares for a ride on this biplane belonging to Berger Aviation Company. Whether she actually flew is not recorded.

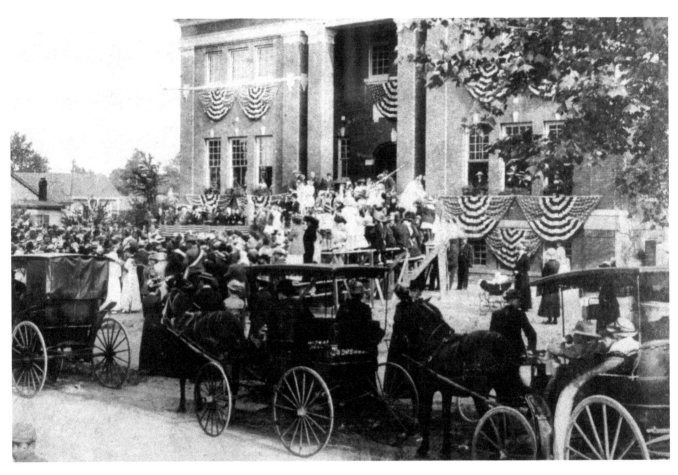

A crowd gathers in 1912 to dedicate Isaac Bear School, located on Market Street near the intersection with Thirteenth Street. Little could they guess that 35 years later the building would become home to newly founded Wilmington College.

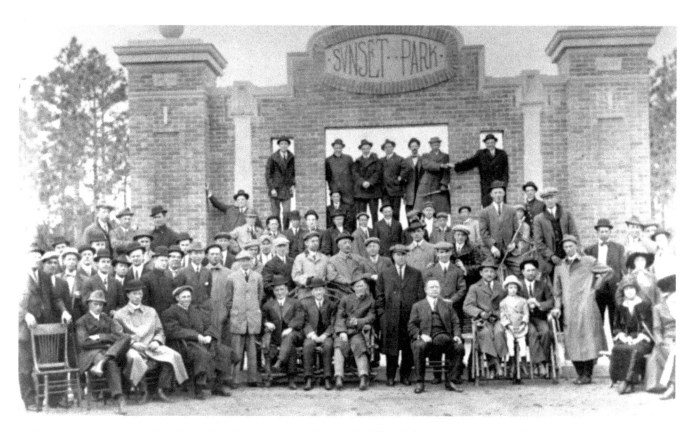

In 1913, the Baltimore Orioles held spring training in Fayetteville. The Philadelphia Nationals, also training in North Carolina, scheduled a number of exhibition games with the Orioles, including one in Wilmington on March 22. This picture, recorded on March 20 at Sunset Park, is part of the welcoming ceremony extended by the Port City.

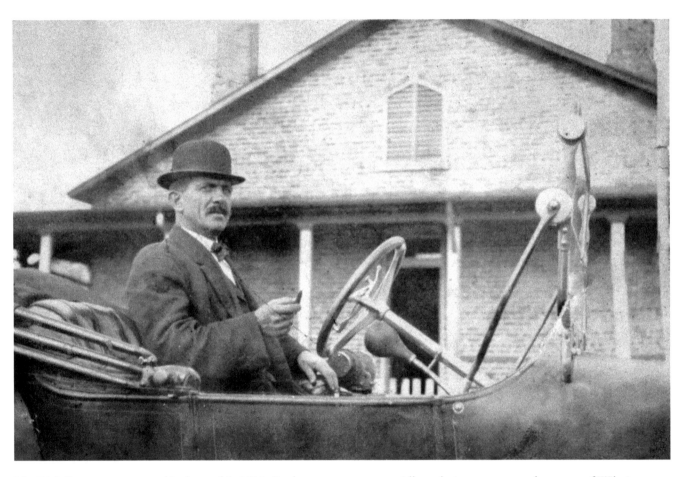

Mr. Dick Burnett prepares to hit the road in 1913. By that year, cars were rapidly replacing wagons on the streets of Wilmington. Their popularity led to road paving and, in the 1920s, to the bridging of the Cape Fear River.

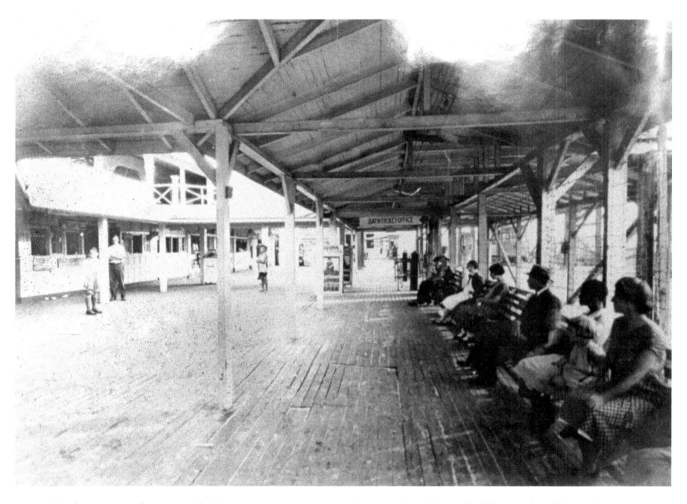

The destination of many Beach Car passengers was Lumina, Station 7 (and the end) of the Wrightsville Beach Line. Lumina Pavilion (opened in 1905 and used until its demolition in 1973) provided dancing, bathing, movies, and games for several generations of area residents. Worn out from all the fun, these people await the trolley at Lumina Station.

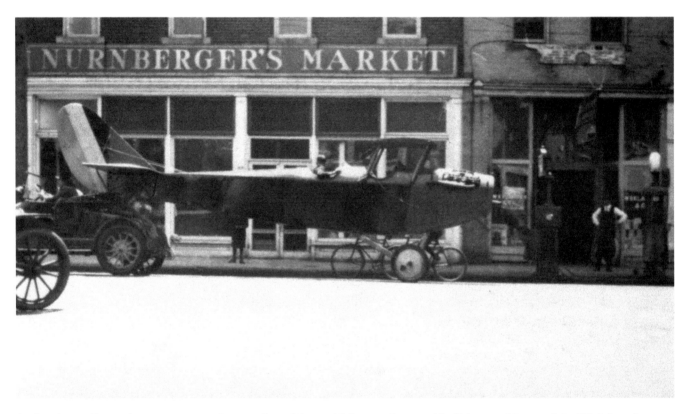

As the air over France began to capture the attention of the world, interest increased in flying machines and the "Knights of the Air" flying them in combat. On this day around 1915, Nurnberger's meat market likely got less attention than the biplane parked in front of it.

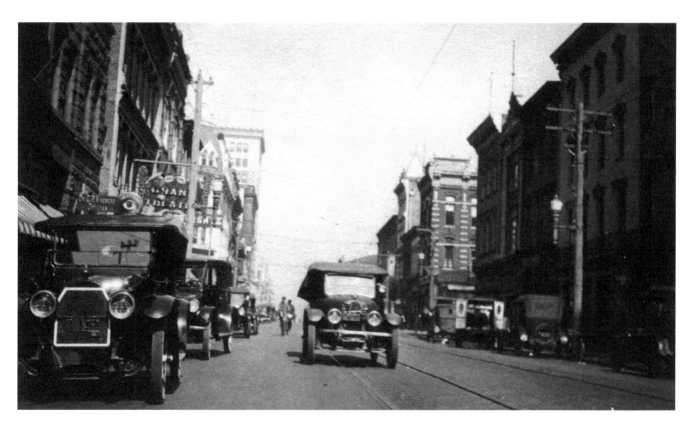

A car bounces along the trolley tracks around 1915 on a Front Street crowded with automobile traffic, including delivery trucks. The Grand Theater, on the left, operated from 1913 to 1923, and housed various retail establishments thereafter. The theater and the Masonic Building to its left still stand today.

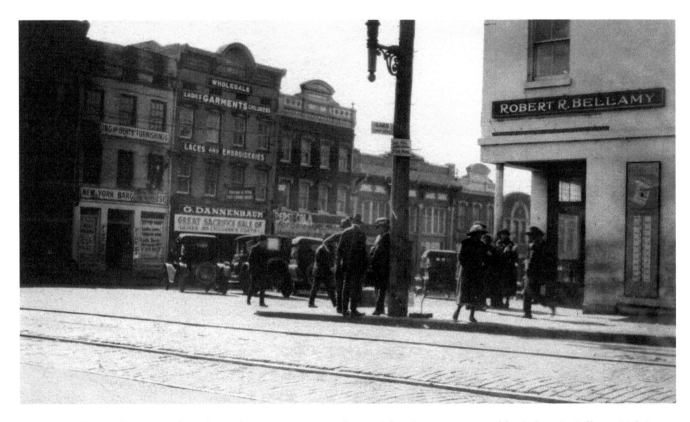

Customers shop at the corner of Market and Front streets around 1915. The pharmacy operated by Robert R. Bellamy (right), established in 1885, continued in business until 1930. G. Dannenbaum's Store for Women (across the street), despite its "Great Sacrifice Sale," also continued operations into the 1930s.

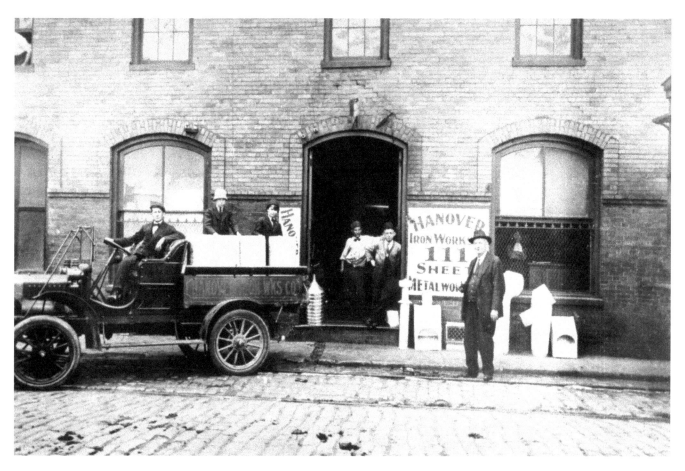

Hanover Iron Works occupied this building on Water Street around 1915. The youngsters in the delivery truck are rough-and-ready for a bumpy ride along the cobbled pavement.

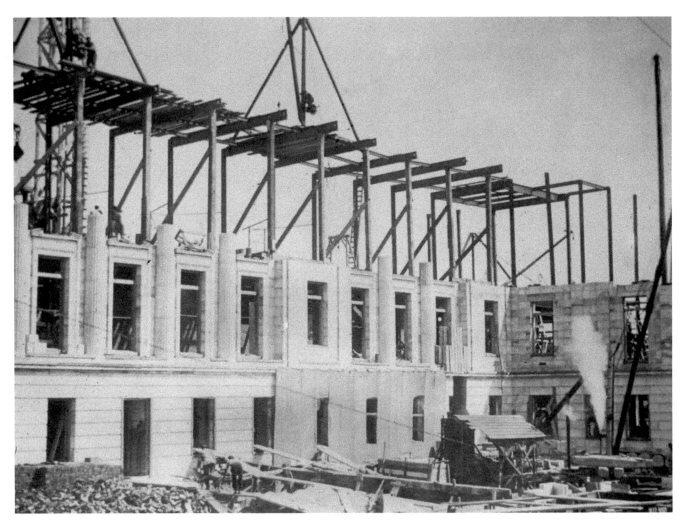

In 1915, workmen demolished the old Customs House (dating from 1843) and adjacent buildings on Water Street to make room for a larger building. Completed in 1916, the United States Customs House is better known today as the Federal Building.

From its opening in 1901, the James Walker Memorial Hospital practiced teaching as well as healing. Dr. Herbert Codington, Sr., poses with a group of interns here in 1916. It is highly probable that within the next two years some of these young men would see the results of the trench warfare then raging in Europe.

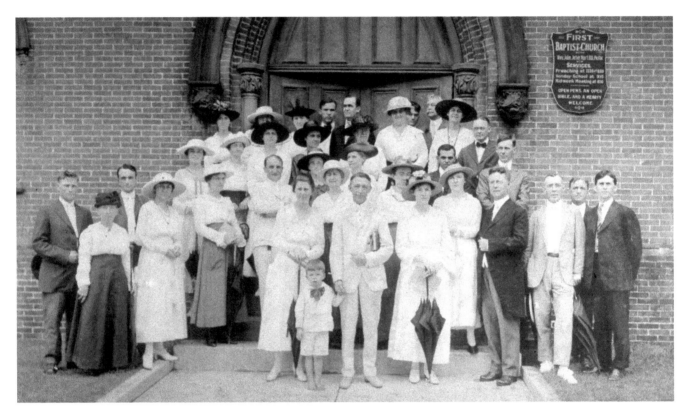

Part of the congregation gathered on the steps of First Baptist Church in 1916. It was a good time for solemn faces and heartfelt prayer, as only a year remained before the United States—and Wilmington—would enter the Great War.

FROM GREAT WAR TO GREAT DEPRESSION

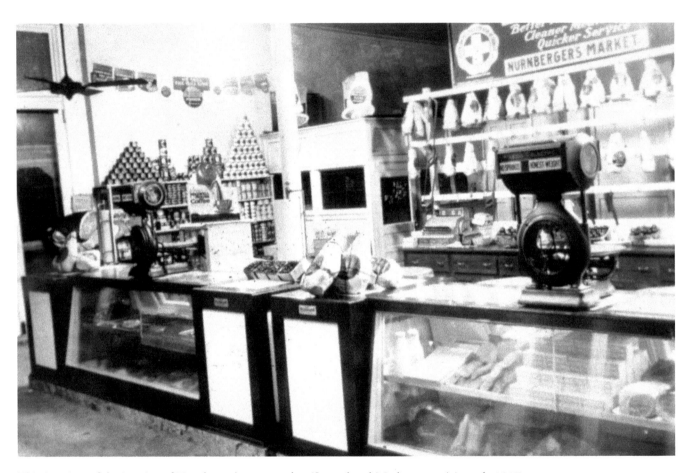

This is a view of the interior of Nurnberger's meat market (Second and Market streets) in early 1917.

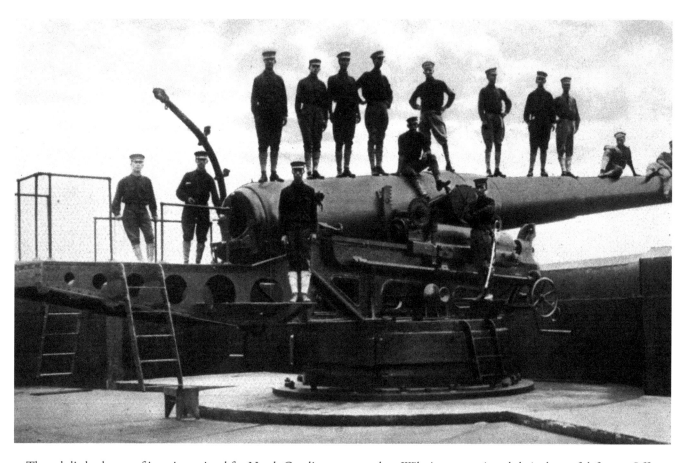

Though little chance of invasion existed for North Carolina, ports such as Wilmington stationed their share of defenses. Officers and crew of a 12-inch gun mounted at Fort Caswell pose for the camera in 1918, waiting patiently for the German raiders who never came.

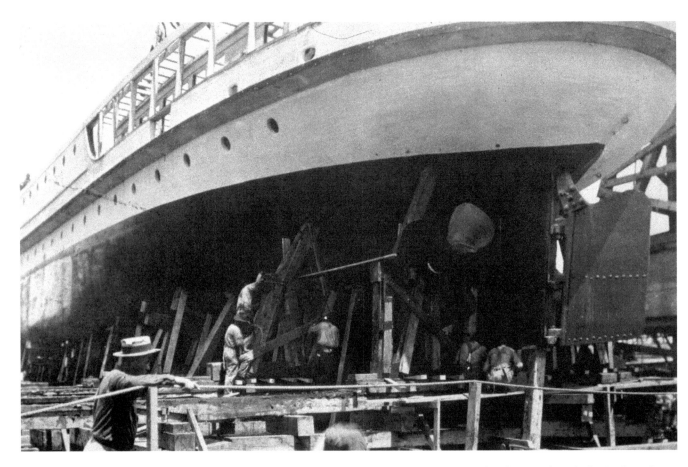

Owing to shortages of steel in 1917, orders were placed for more than 30 "Concrete Cargo Ships"—vessels with five inches of concrete added to their hulls. Shipyards, such as the Liberty Shipyard at the foot of Greenfield Street (shown here in 1918), managed to complete only a dozen of those vessels. All proved less than adequate while at sea.

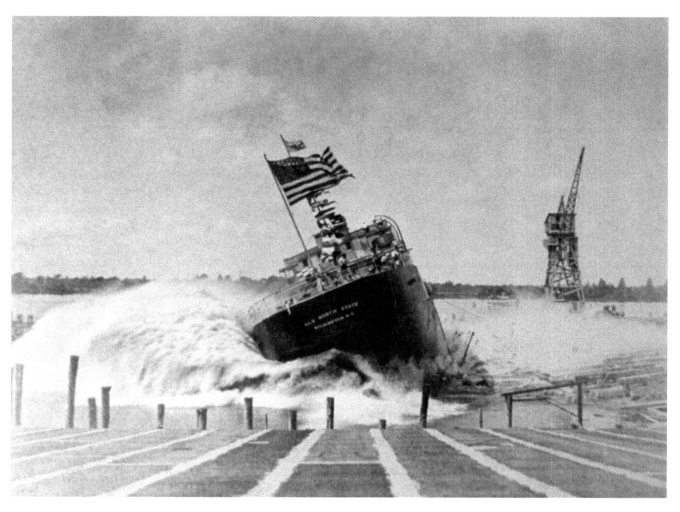

Liberty Shipyard managed to launch a concrete ship in 1919, too late to support the war effort but on time to return soldiers to the United States.

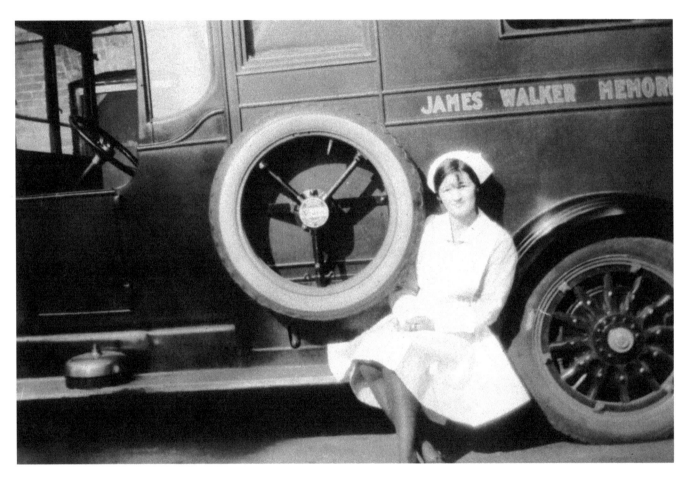

Motorized ambulances appeared at James Walker Memorial Hospital around 1919.

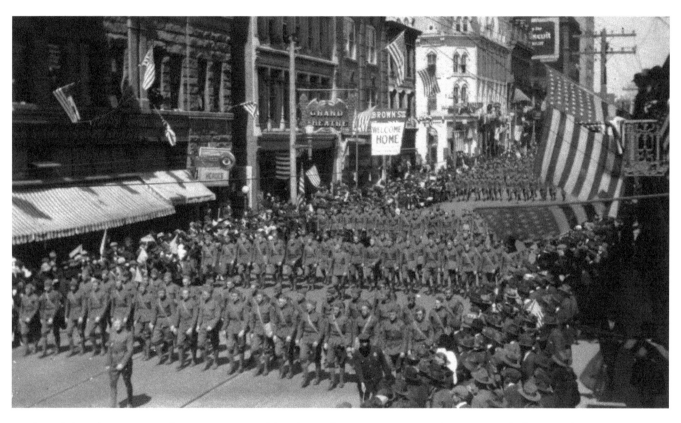

Crowds line the street to welcome American soldiers home from Europe on March 30, 1919. The lead marchers are passing the Masonic Building on Front Street, with the Grand Theater just beyond.

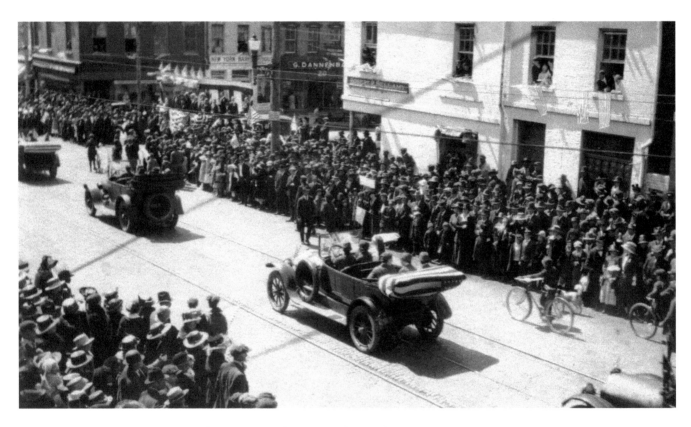

Officers and civilians follow the marching troops as they pass Bellamy's Pharmacy on Front Street.

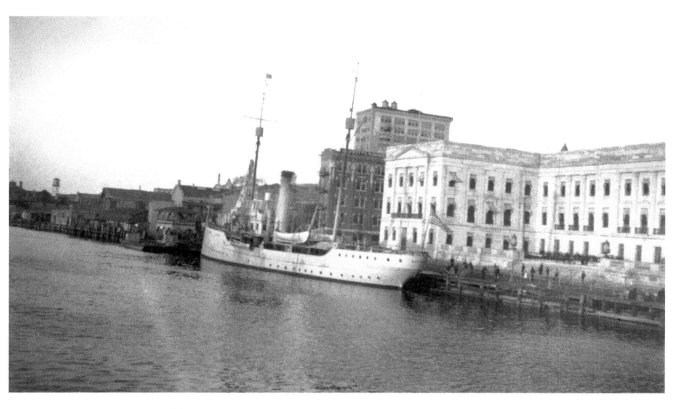

The USCG Cutter *Seminole* berthed at Wilmington for many years. Pictured here around 1919, she is moored in front of the Customs Building. It was from here that the cutter sailed in January 1921 to become a part of the mystery of the *Carroll A. Deering*, a ship that ran aground in North Carolina with no trace of its crew.

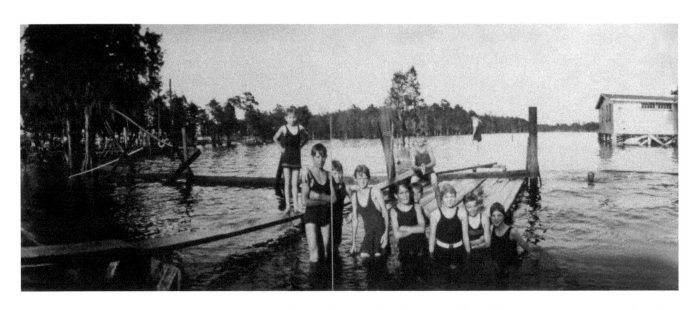

A popular swimming spot for years, the city purchased Greenfield's and McIlhenny's Mill pond in 1928 (some ten years after this photograph). During the Great Depression, WPA workers dug drainage ditches and constructed the five-mile-long Community Drive around the site, turning it into the lovely Greenfield Park that many Wilmingtonians would later enjoy in youth.

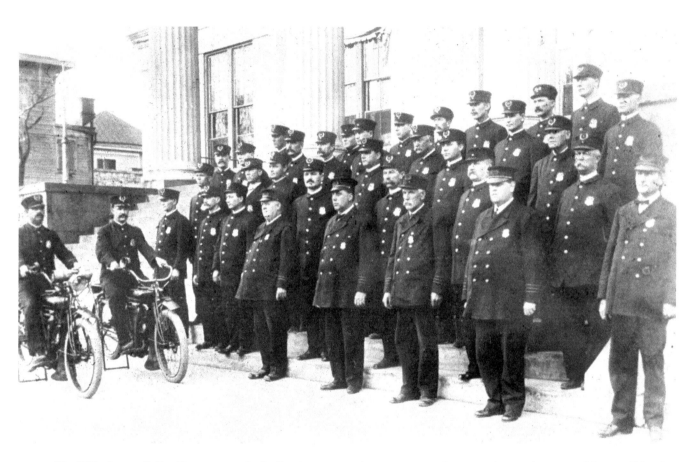

The Wilmington Police Department, including its motorcycle troop, snapped to attention on the steps of City Hall for this photograph in 1918.

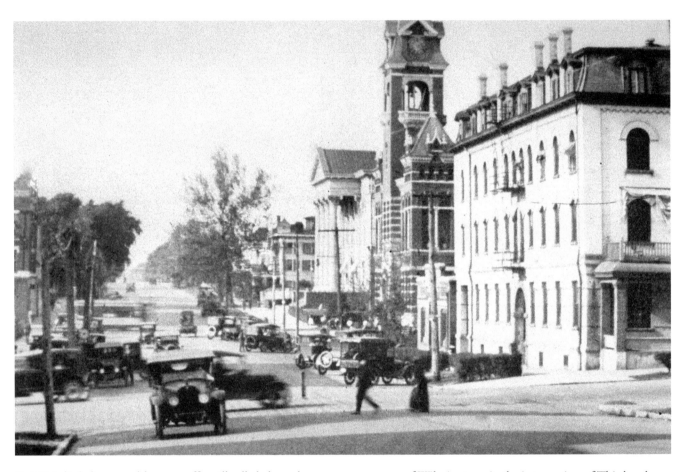

By 1919, little horse-and-buggy traffic still rolled along the prosperous streets of Wilmington. At the intersection of Third and Market streets, however, other traffic (unregulated by sign or light) seemed heavy.

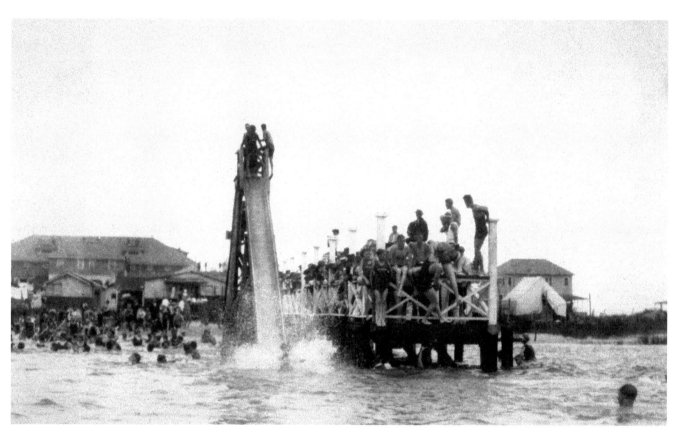

The Lumina Pavilion stretched across the island at Wrightsville Beach. Shown here around 1919, the side facing the sound was especially popular, featuring a pier, water-sliding board, and swimming area.

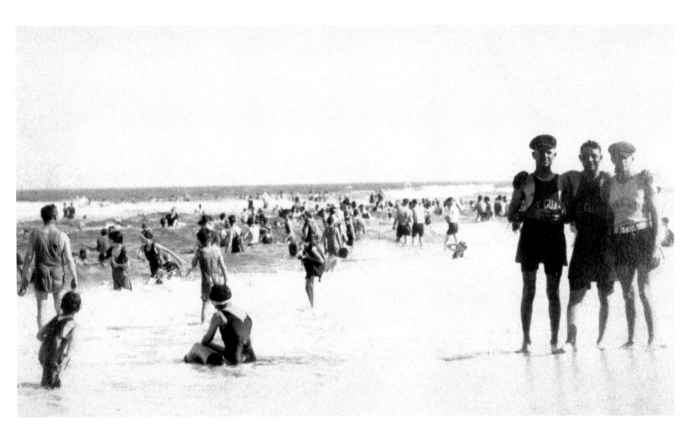

The Atlantic side of Lumina may have been even more popular than the sound side.

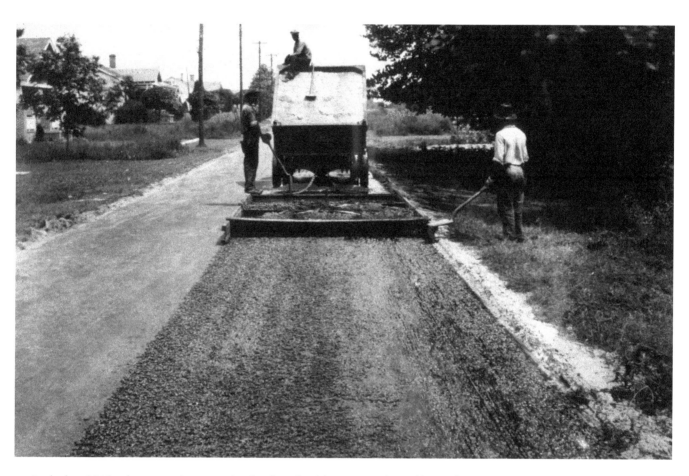

In the late 1910s, the county began tarring local roads with a process devised by Dick Burnett, Superintendent of County Road Construction. Car owners loved the idea, until heavy rain and traffic began to take their toll, creating potholes.

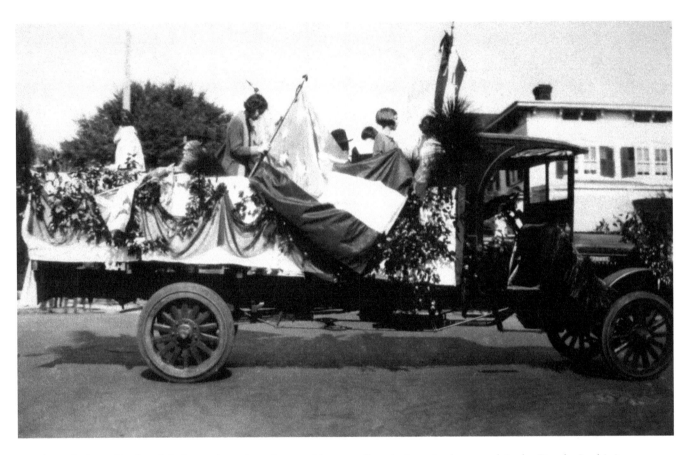

People in the Port City loved their parades, a love that would eventually culminate in the annual Azalea Parade. In this image, a truck has been converted into an impromptu float sometime in the late 1910s.

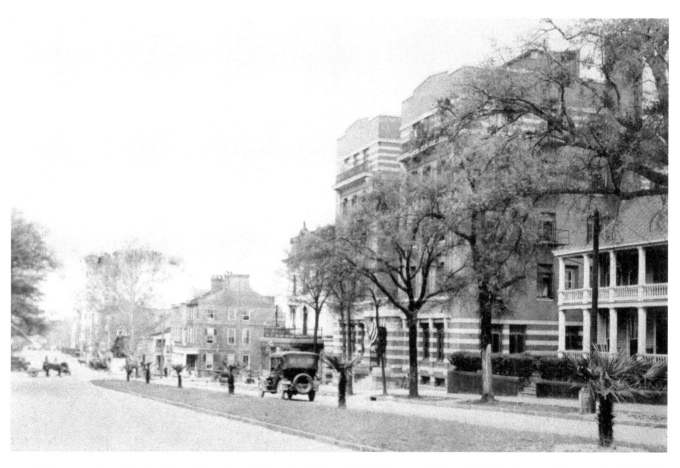

A view west along Market Street from Fourth Street in the late 1910s features (right to left) Dr. Cranmer's house, the Y.M.C.A. (with the white horizontal stripes), the deRosset House, and the Potter House.

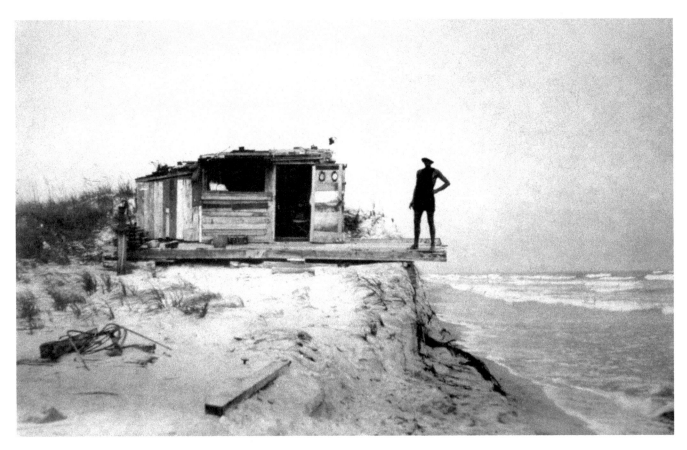

Shown here in the late 1910s, Walter Winter's fishing shack at Fort Fisher, like most of the original seaward portion of Fort Fisher, fell victim to erosion many years ago. Efforts to stabilize erosion at the state park continue to this day.

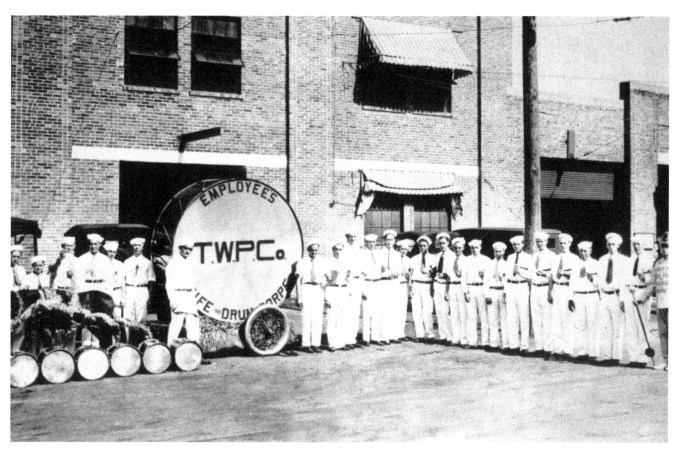

Tide Water Power Company sponsored an employee band in the late 1910s. In this picture, Bert Kite is the director.

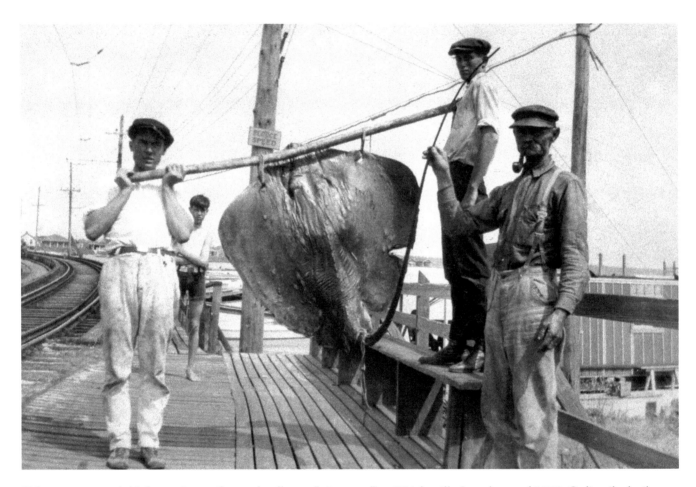

Fishermen captured this large stingray (known locally as a "sting-a-ree") at Wrightsville Sound around 1925. Ordinarily docile creatures, rays nevertheless pack a barbed, and dangerous, tail.

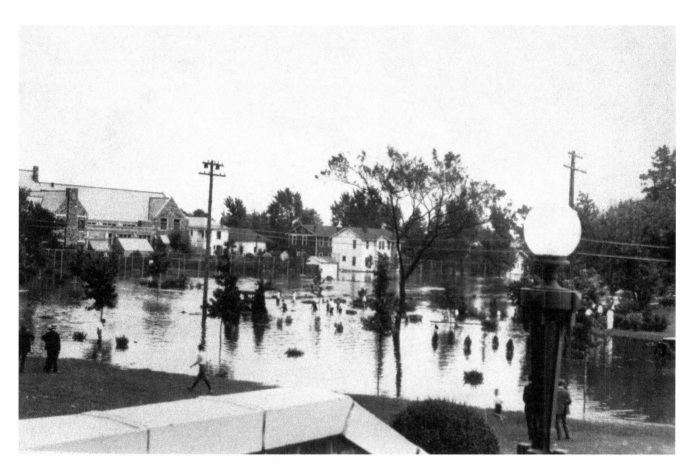

A high water-table, frequent deluges from thunderstorms, and less frequent hurricanes have made local flooding a continuing challenge for the Wilmington area. Sometime after 1922, a camera captured this flooding near Market Street from the steps of New Hanover High School.

Beach erosion in the Wilmington region is nothing new (nor a problem with an end in sight). Across the years, numerous attempts have been made to curb it, including a series of wooden jetties installed at Wrightsville Beach in the 1920s—the construction in view here is under way in 1923. Such attempts have met, at best, with limited success.

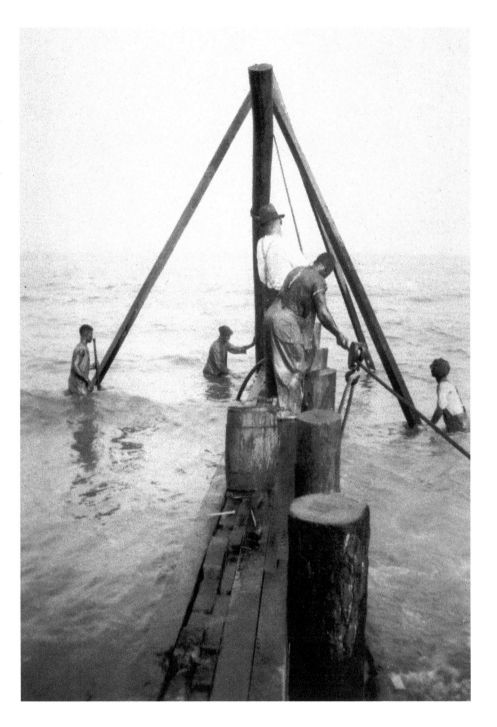

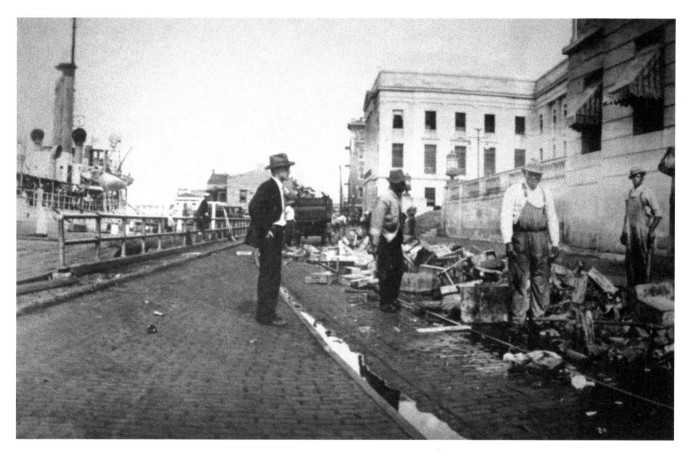

Prohibition in North Carolina began in 1909, but between 1920 and 1933, the years of national prohibition, federal agencies prosecuted those who distilled and smuggled illegal liquor. As a port city teeming with waterways and beaches, Wilmington became a bootlegger's paradise. Shown here in the mid-1920s, a federal agent supervises the destruction of illicit booze near the steps of the Customs House. Alcohol seemed to reach nightspots such as the Lumina Pavilion, despite state and federal diligence.

A camera captures Princess Street near Third Street around 1924. Clean, busy streets flanked by electric streetlights and even public trashcans convey an aura of prosperity to the scene. It appears that Colonial Building & Loan Association (at right) has a few customers. The easy credit of the 1920s would return to haunt borrowers (state and local governments as well as private citizens) by the end of the decade.

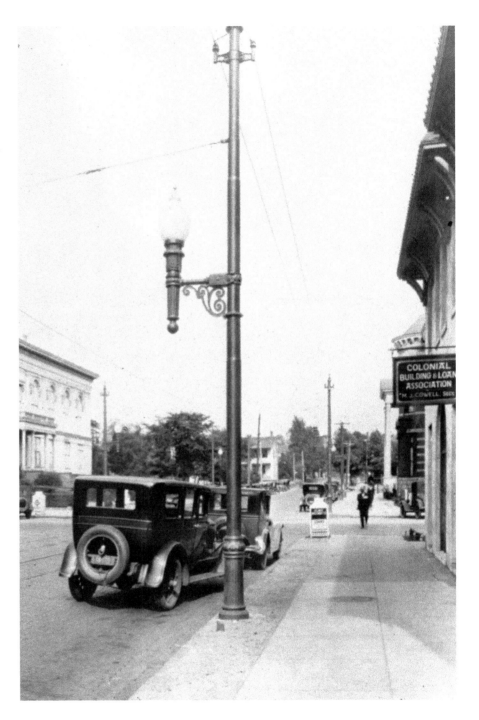

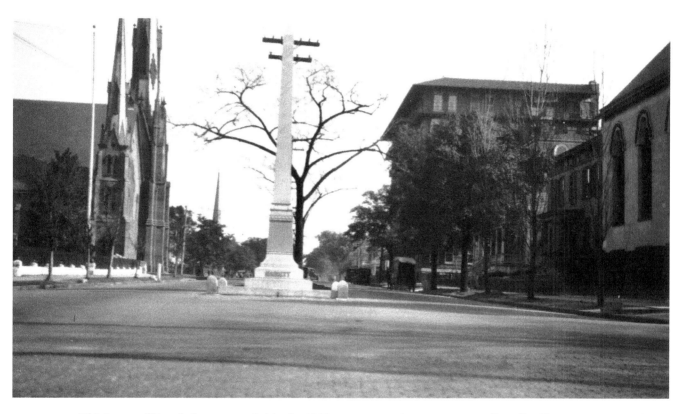

This image of Fourth Street, recorded in the 1920s, centers on the monument to Cornelius Harnett, representative to the Continental Congress. On the right are the rear of the Temple of Israel and the Carolina Apartments. Opposite the apartments stands the First Baptist Church.

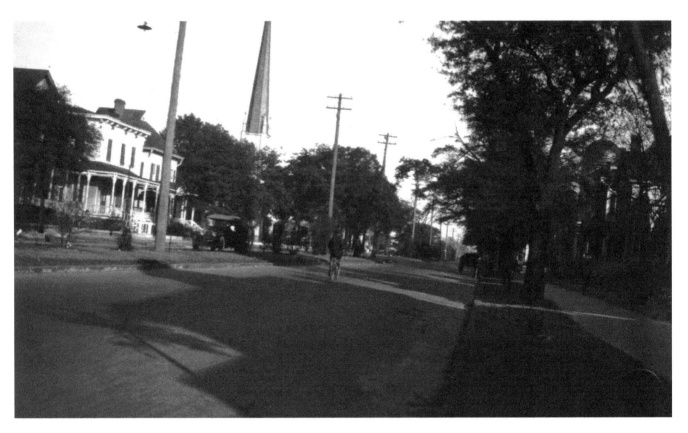

The steeple of St. Paul's Lutheran Church towers over Market Street between Fifth and Sixth streets in the 1920s.

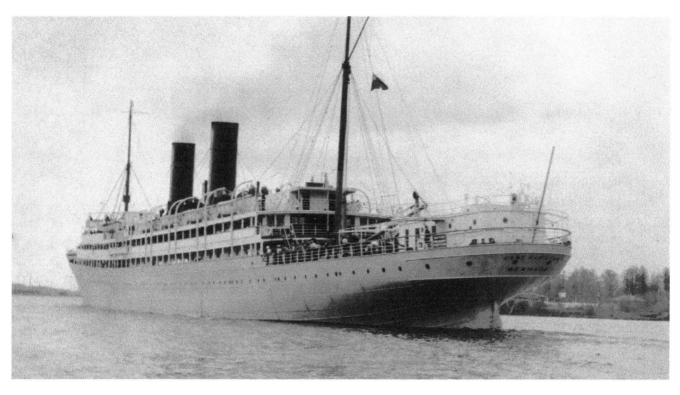

On February 21, 1925, the cruise ship *Fort Hamilton,* registered in Bermuda, docked at Wilmington on the first of several visits in an attempt to establish a regular cruise line in the Port City.

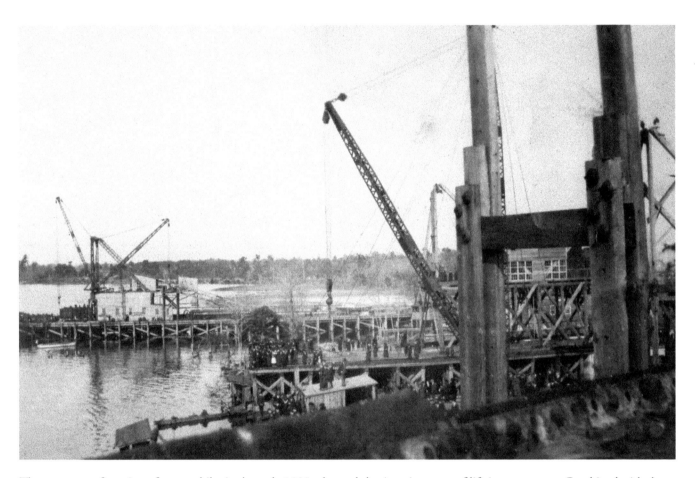

The mass manufacturing of automobiles in the early 1900s changed the American way of life in many ways. Combined with the tourism industry, which began assuming tremendous importance on the Carolina Coast in the 1920s, this introduced a desire to connect the many barrier islands and once pristine beaches. In 1925, construction began on a causeway to join Harbor Island (also known as the Hammocks) to the mainland.

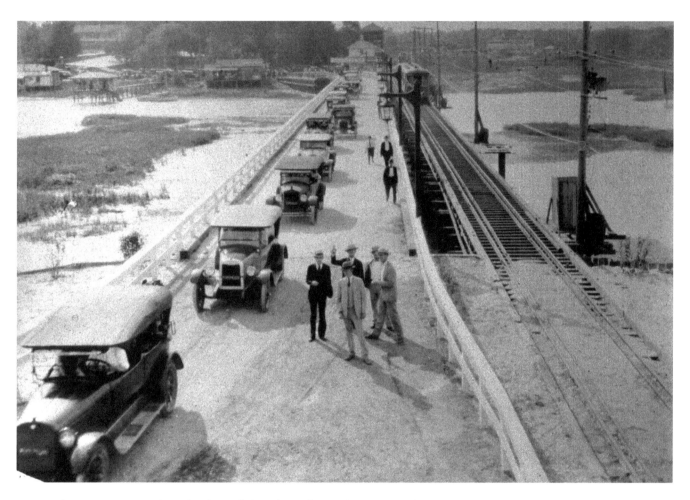

The causeway to Harbor Island, paralleling the trolley track across Wrightsville Sound, opened in 1925. A second causeway, opened in 1926, joined Wrightsville Beach to the mainland. The opening of these causeways was the beginning of the end for the old electric Beach Trolley, though few people suspected it at the time.

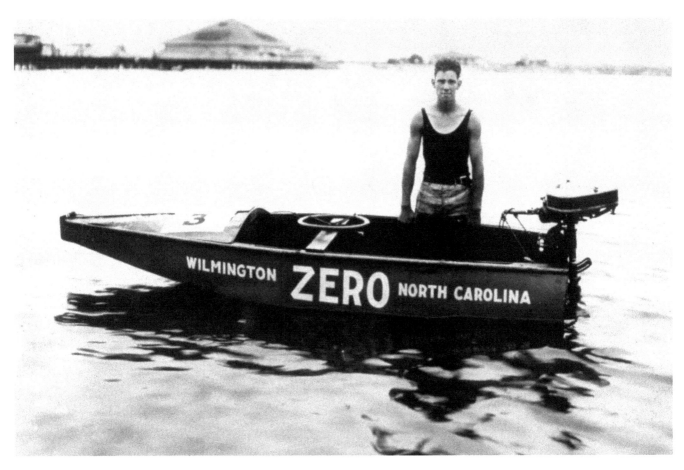

In the 1920s, motorboat racing in Banks Sound and along the Cape Fear River became popular. Gene Pickard, age 16, poses with his boat, *Zero.*

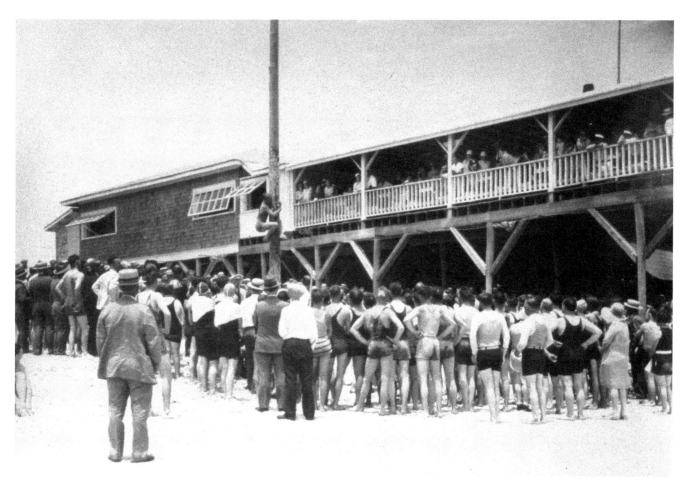

A small crowd cheers the competitors onward (or upward!) in a greased pole contest in the 1920s. Athletic competitions at Lumina drew big crowds on the Fourth of July and Labor Day.

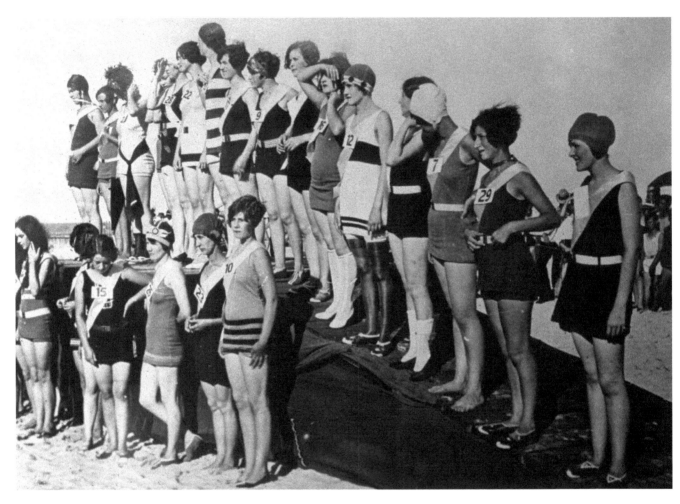

Bathing beauty contests at Lumina, this one in 1927, attracted far more viewers than greased-pole contests.

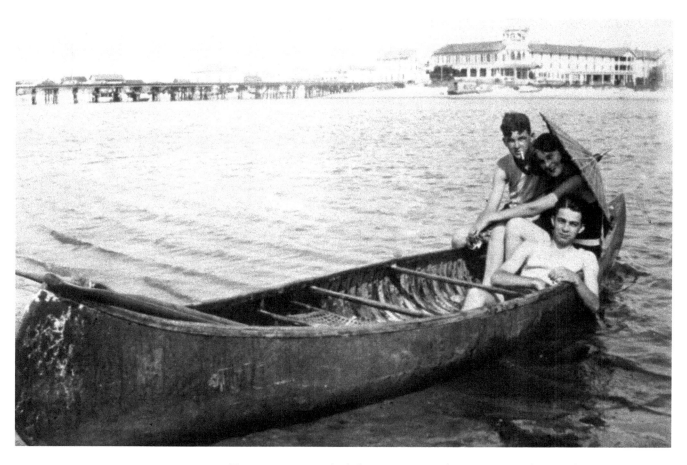

Two young men and a lady enjoy a sunny day canoeing on the sound off Harbor Island.

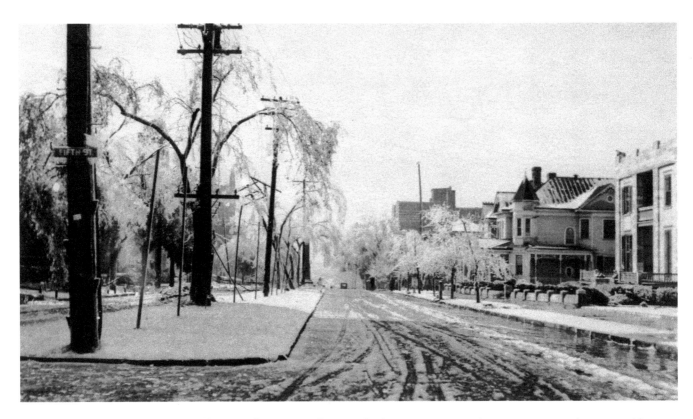

As this chilly view at Market and Fifth streets illustrates, Wilmington's pleasant average yearly temperature can be trumped by the actual temperature on any given day. The photograph shows the aftermath of snowfall and a destructive ice storm, which has severed large tree limbs and left trees and utility lines drooping.

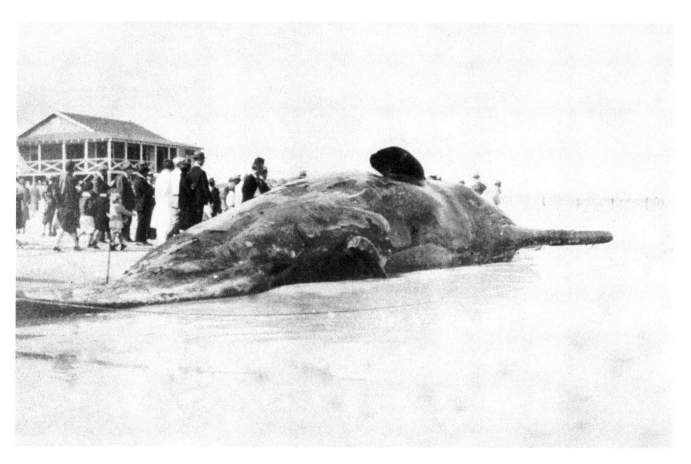

A 50-ton sperm whale washed ashore at Wrightsville Beach in 1928. Tourists flocked to see it—until the smell reached epic proportions. The remnant of the rotting carcass made its way to the North Carolina Museum of Natural History in Raleigh.

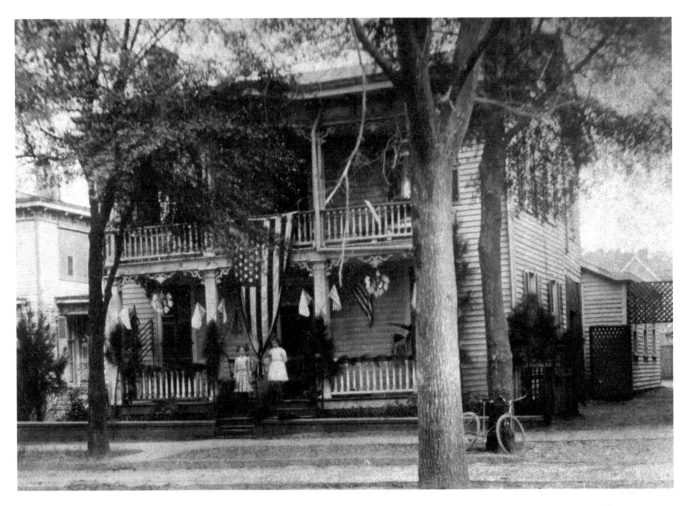

Homes in the Port City caught the spirit of the Feast of Pirates. But these decorations on the Carpenter House on Fifth Street were put in storage for the last time in 1929. Only a few short weeks later, Wall Street's crash signaled a new period in the history of Wilmington: the Great Depression.

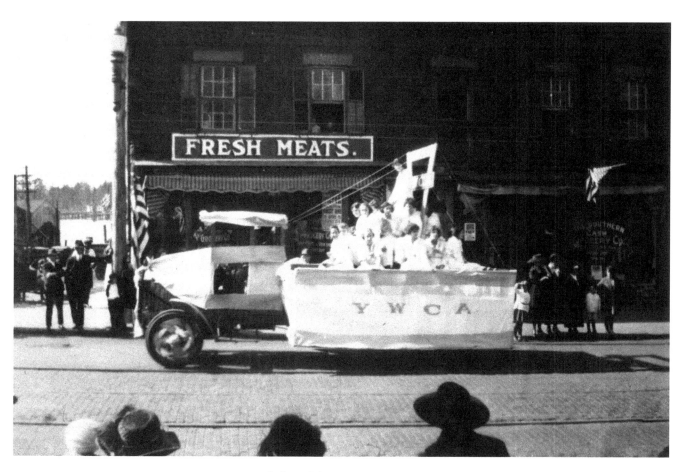

Young ladies of the Y.W.C.A. participate in a Feast of Pirates parade along Front Street.

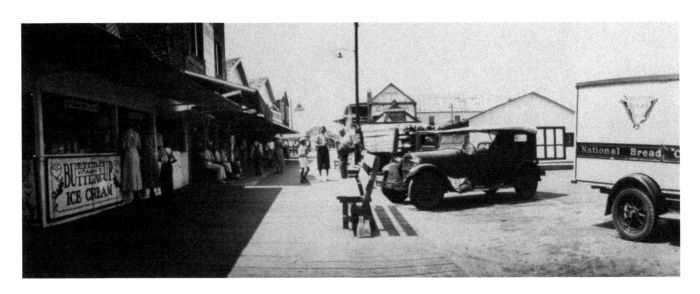

The Carolina Beach Boardwalk, around 1930, became the beach of choice for the average tourist because of its growing commercial district, the myriad entertainments along its boardwalk, and especially thanks to its cheaper hotels. Tourists from afar able to afford a vacation during the Great Depression, however, were declining in number.

FOUR DECADES OF CHANGE

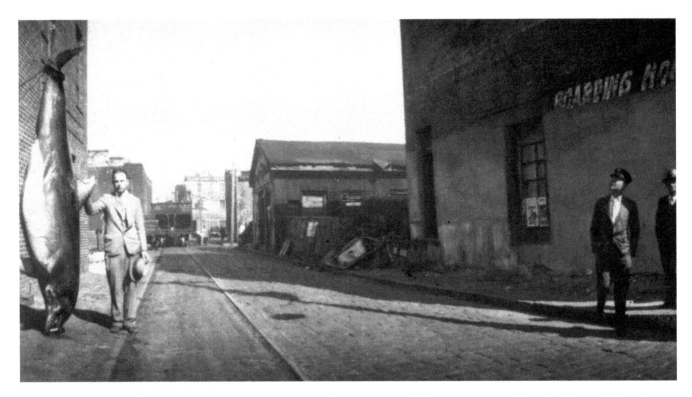

Now that's a fish! Actually, it is a sturgeon caught in 1940 in this photograph of the intersection of Muter's Alley and Water Street. The old Ice House is on the right, and it will take loads of ice to cool that impressive catch (a very uncommon catch in the Cape Fear River by the 1940s).

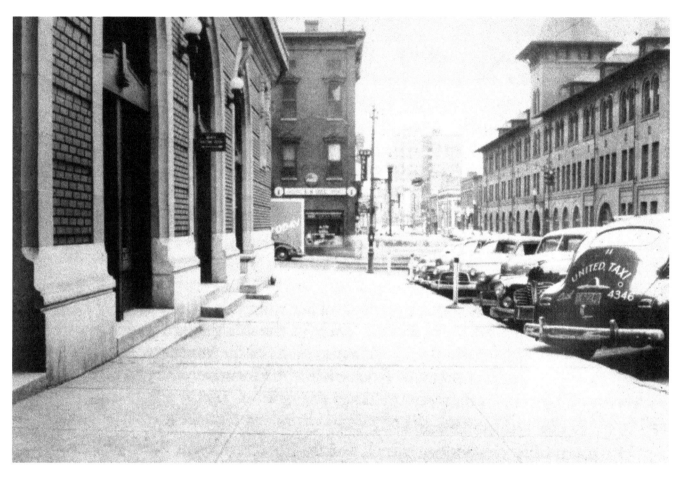

Taxis wait at Union Station on Front and Red Cross streets around 1940. Across Front Street is the old Atlantic Coast Line General Office and across Red Cross is the old Atlantic Hotel, now a retail establishment.

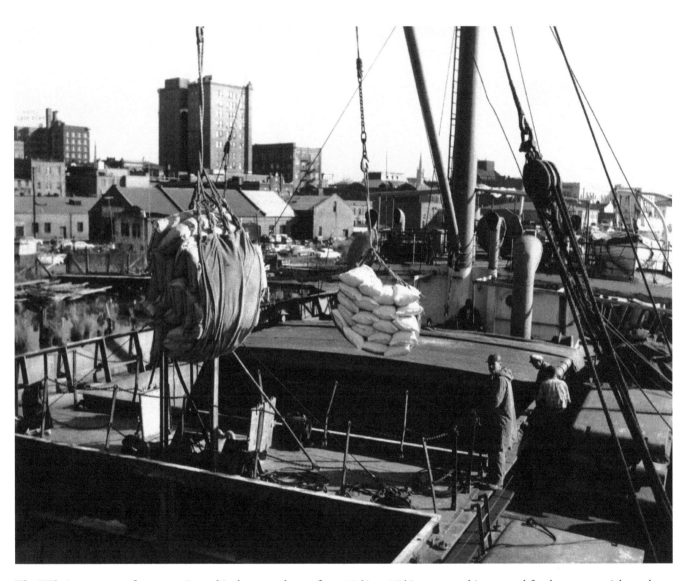

The Wilmington waterfront experienced its last great boom from 1941 to 1945, as cargo ships moved food, raw materials, and finished goods to support the troops fighting World War II in Europe and the Pacific. Shown here, cargo is shifted to the hold of a small merchantman. After 1941, such vessels faced German U-boats once they left the mouth of the Cape Fear River.

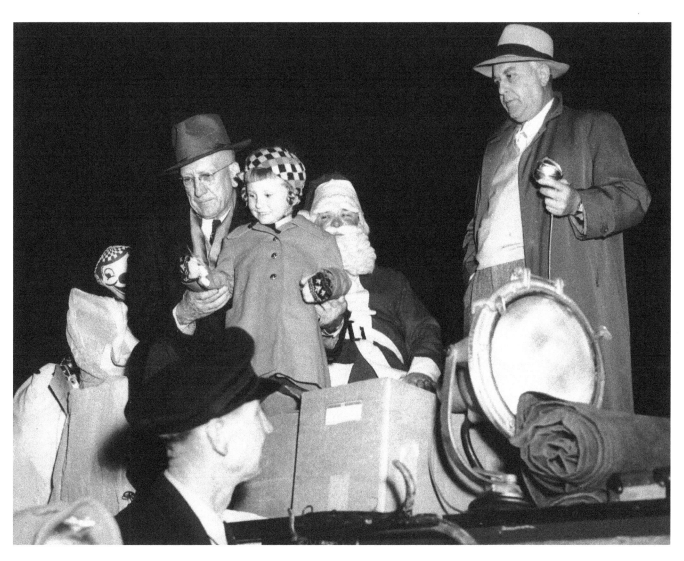

This is a publicity shot of Mayor Royce S. McClelland, snapped around 1950. Upstaging Santa Claus had to be a nifty political coup!

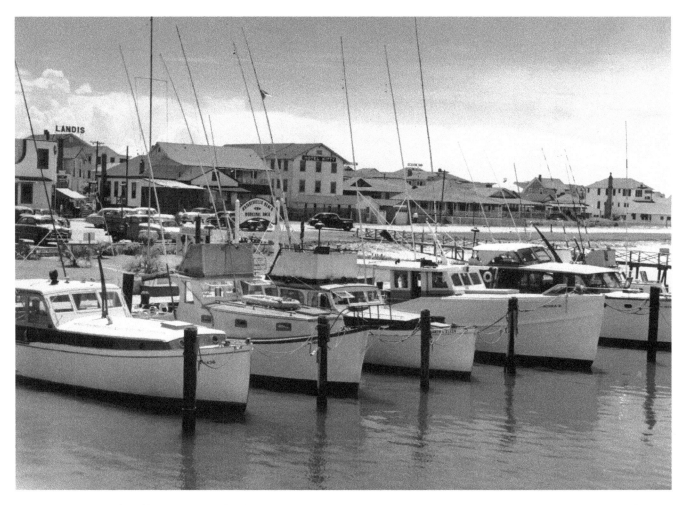

The marinas at Wrightsville Beach teemed with lovely boats in the early 1950s. In October 1954, however, Hurricane Hazel slammed ashore with 140 M.P.H. winds, leaving more than $7,000,000 of damage and numerous fatalities in North Carolina as its legacy.

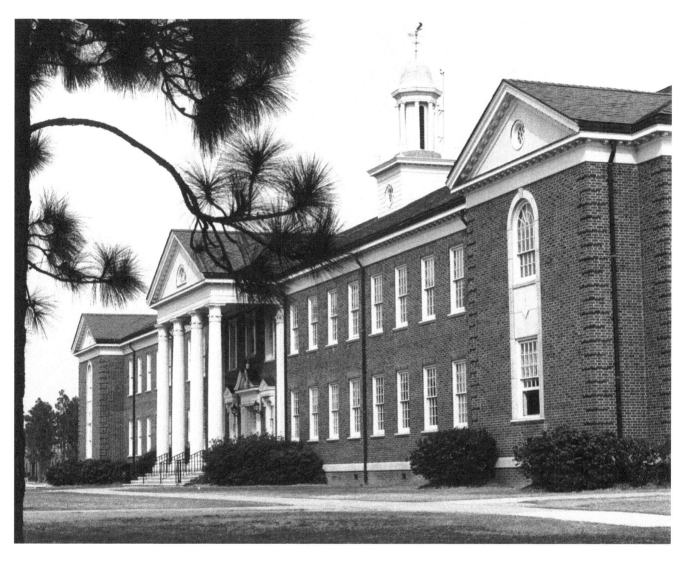

Wilmington College opened in 1947 at the old Isaac Bear School building on Market Street. In 1968, the college achieved university status as the University of North Carolina at Wilmington. Today, the College Road campus is one of the most beautiful and dynamic in North Carolina's university system. This view of Hoggard Hall dates from the 1960s.

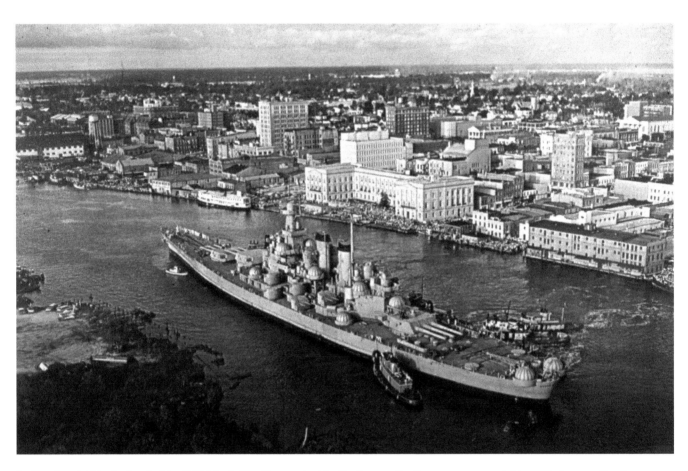

In October 1961, the battleship USS *North Carolina* reached its final port of call as a war memorial in Wilmington. Partly financed with money collected by schoolchildren, the "showboat" remains docked at Eagle Island, where its sound and light show continues to amaze and educate thousands of tourists every year.

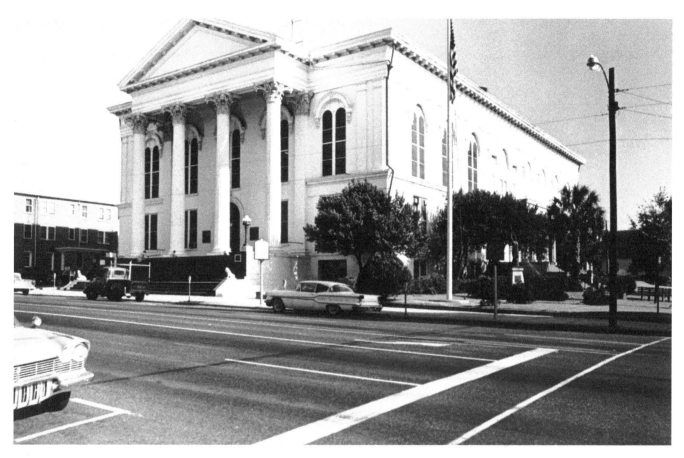

In the 1960s, well-meaning groups and government leveled many older buildings in the name of urban renewal. Fortunately, Wilmington's historic City Hall survived.

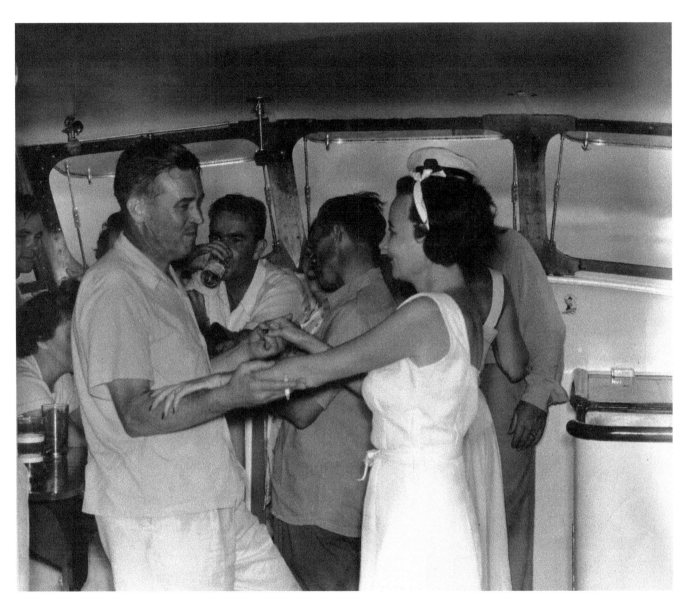

The heritage of Wilmington residents remains tied to water and boating. Here in the 1960s, Harriet Bellamy McDonald and friends take a small cabin cruiser to celebrate life and the pleasure of living in Wilmington.

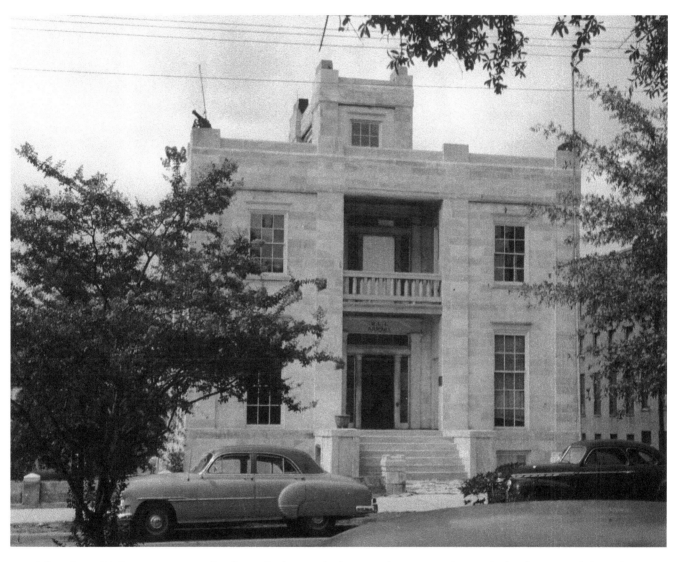

The John A. Taylor House on Market Street, built in 1847, has served as a private home, the headquarters of the Wilmington Light Infantry, the location of the Wilmington Public Library, and has been used by First Baptist Church. This photo was snapped in the 1960s while it housed the public library.

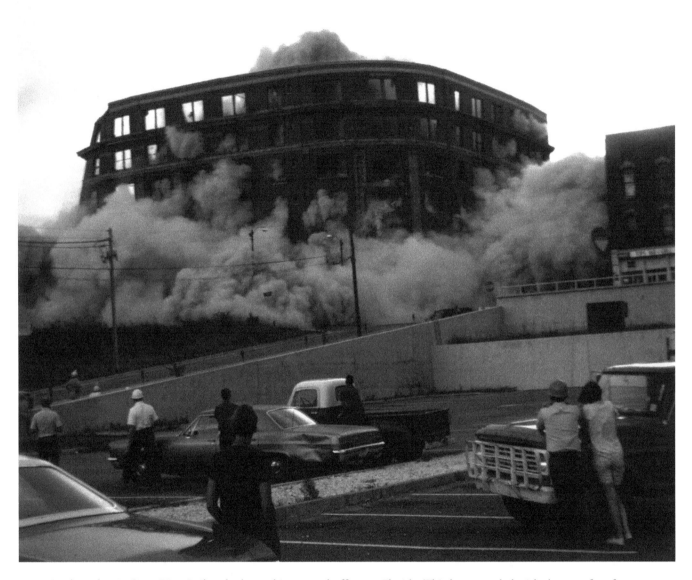

In 1960, the Atlantic Coast Line Railroad relocated its general offices to Florida. This loss, coupled with the transfer of port traffic to Port Authority's terminal downriver (ongoing after 1945), left vacant buildings to rot along the riverfront. In 1970, the city demolished the abandoned Union Station. Perhaps it gave closure to the loss of the ACL, but the dynamite also destroyed a marvelous bit of architecture. The loss of Union Station helped to light the fuse for historic preservation.

Notes on the Photographs

These notes, listed by page number, attempt to include all aspects known of the photographs. Each of the photographs is identified by the page number, a title or description, photographer and collection, archive, and call or box number when applicable. Although every attempt was made to collect all data, in some cases complete data may have been unavailable due to the age and condition of some of the photographs and records.

Printed in the USA
CPSIA information can be obtained
at www.ICGtesting.com
JSHW072026140824
68134JS00042B/3803